The
GOOD
INN

The GOOD INN

An Illustrated Screen Story of
Historical Fiction

Black Francis
& Josh Frank

with drawings by
Steven Appleby

THE GOOD INN. Copyright © 2014 by Charles Thompson and Josh Frank. All rights reserved. Printed in the United States of America. No part of this book may be used or reproduced in any manner whatsoever without written permission except in the case of brief quotations embodied in critical articles and reviews. For information address HarperCollins Publishers, 10 East 53rd Street, New York, NY 10022.

HarperCollins books may be purchased for educational, business, or sales promotional use. For information please e-mail the Special Markets Department at SPsales@harpercollins.com.

Illustrations © 2014 by Steven Appleby, Charles Thompson, and Josh Frank

FIRST EDITION

Designed by Paula Russell Szafranski

Library of Congress Cataloging-in-Publication Data

Black, Frank, 1965–
 The Good Inn : an Illustrated Screen Story of Historical Fiction / by Black Francis and Josh Frank ; with illustrations by Steven Appleby.—First edition.
 pages cm
 ISBN 978-0-06-222079-0 (hardback)
 1. Graphic novels. I. Frank, Josh. II. Appleby, Steven, illustrator. III. Title.
PN6727.B584 2014
741.5'973—dc23
 2013043036

14 15 16 17 18 ov / RRD 10 9 8 7 6 5 4 3 2 1

Black Francis dedicates this book to:

Joey Santiago, David Lovering, and Kim Deal

Josh Frank dedicates this book to:

Jessica Frank

In memory of
Joe, Abe, Irwin, and Moe

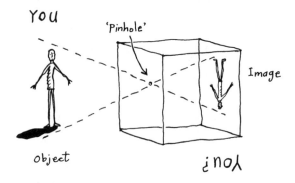

YOU

'Pinhole'

Image

object

¿noY

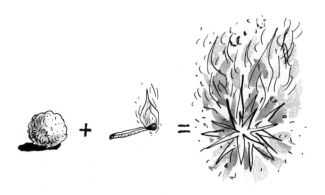

O=N⁺ with O and O⁻ ... Nitrocellulose

Guncotton

Nitrocellulose

Guncotton

$3HNO_3 + C_6H_{10}O_5 \rightarrow C_6H_7(NO_2)_3O_5 + 3H_2O$

Guncotton

Aux armes, citoyens . . .
To arms, citizens . . .

Nous entrerons dans la carrière
We shall enter the (military) career

Quand nos aînés n'y seront plus,
When our elders are no longer there,

Nous y trouverons leur poussière
There we shall find their dust

Et la trace de leurs vertus (bis)
And the trace of their virtues *(repeat)*

(Children's Verse)

Bien moins jaloux de leur survivre
Much less wanting to survive them

Que de partager leur cercueil,
Than to share their coffins,

Nous aurons le sublime orgueil
We shall have the sublime pride

De les venger ou de les suivre
Of avenging or of following them

—"WAR SONG FOR THE ARMY OF THE RHINE"

The cinema is an invention without any future . . .

—AUGUSTE AND LOUIS LUMIÈRE

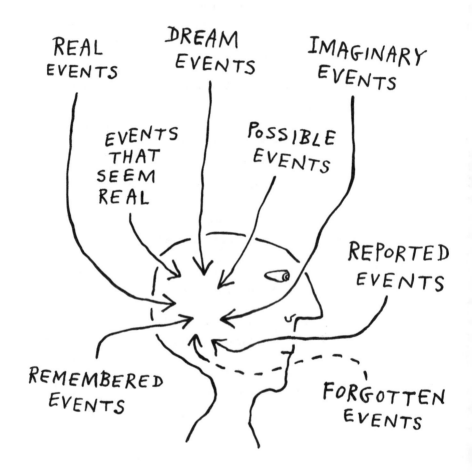

Contents

Introduction: Waiting for Guncotton x

Prologue 1

ACT I: Guncotton

Chapter 1: The Guncotton Investigation 15

Chapter 2: Wandering 33

ACT II: The Good Inn

Chapter 3: Under the Golden Shield at the Good Inn 59

Chapter 4: The Blue Movie 91

Inter-Mission: Meanwhile . . . 101

ACT III: The City of Light

Chapter 5: The Mouth of the Rhône 133

Chapter 6: In the Pigalle 161

Chapter 7: La Maison Rouge du Film Bleu

(The Red House of the Blue Movie) 197

Epilogue 229

Acknowledgments 233

How a BOOK based on a SOUNDTRACK score THAT HAD NOT YET BEEN COMPOSED about the FIRST NARRATIVE pornographic MOVIE FOR A FEATURE FILM that DID NOT YET EXIST came to BE

Introduction

Waiting for Guncotton *(or)* ⌐

A few years ago, my friend Charles Thompson (a.k.a. Frank Black, a.k.a. Black Francis, front man and founder of the band the Pixies) sat down with me at a little French café on the East Side of Austin, Texas. He was right in the middle of his Pixies *Doolittle* twenty-year anniversary tour. I'd brought him here because the man loves all things French. This was the same guy who named his fourth Pixies album *Trompe Le Monde,* after all, and who would find any excuse to get to Paris. So being the Texas barbecue-bred boy that I was, I had to do some research in order to find a passable French experience in a city that celebrated smoked brisket and ribs. As we took in the aroma of our espressos in the warm and inviting bistro vibe of the Blue Dahlia, I asked him what he wanted to do next. Charles always has exciting new projects in mind and I am always amenable to the cause. Charles and I had become friends over the years, as my first two books concerned topics of interest to him. The first was a book about the Pixies and the second a book about a man named Peter Ivers, who wrote the title song for David Lynch's *Eraserhead.*

Aside from an affinity for France and making music, Charles has always loved the cinema. Sitting at the café, he began to tell me about how he had been struggling to find the right way to bring new Pixies material into the world after it had been absent for so long. He

wanted to create something musically that was completely different and new. He felt that if a filmmaker would come along and ask his band to do a soundtrack for a cool movie, that might be the answer. I had just finished telling him about my latest writing project: a puppet rock-musical movie about a world where people live symbiotic relationships with puppets by sharing their subconscious minds through a device called a "Flip-Chip," invented by a master puppeteer in a world that now hated puppets. He was fascinated by the completely made-up original world and all its possibilities.

As the conversation progressed, he divulged that he actually had an idea for a film. It was the story of the first pornographic movie ever to include a narrative.

He was inspired by a film he'd heard about called *La bonne auberge* (The Good Inn). Set in 1907, it had the meagerest of plots: a soldier goes to an inn and meets the daughter of the innkeeper and they have a lot of sex. Charles had become fascinated by the idea of filling in the blanks to the soldier's backstory, and in an early attempt to find new Pixie-ish inspiration he had even recorded a few demos for songs pertaining to the story, describing it as sort of a soundtrack "song cycle" about a character named simply Soldier Boy. It was at this point that I interrupted him and said, "Wait a minute, you mean you've already started writing the soundtrack to *this* movie?"

From there, everything fell into place.

"Charles, why not write the soundtrack to the movie first? Who says you can't write the music before there's an actual movie to score? If you want to make a movie, you should start with what you know how to do best: the music."

There was a moment of silence while Charles mulled this over. Then he asked me to help him write it. "Write what?" I asked.

"Our movie," he responded.

Now we both took a moment of silence to contemplate the exchange that had just occurred and he asked me what else I had

been up to. I told him that I had recently by chance invented and opened the world's first mini urban drive-in movie theater, which I'd built in a back alley way on the East Side of Austin. We projected on the wall of a church, led by a mariachi band. Charles lit up like the sun: "Wait, you have your own movie theater?" In the purest form, this is Charles, getting excited about a little oddball thing and then being fascinated to the point where he would request that I take him to see it after his show.

So it was eleven thirty P.M. on a Thursday night and I picked Charles up in the back of the theater where he was performing *Doolittle* in Austin, with a two-hour window before his bus left for the next stop on the tour. We drove across town and pulled up into the alley of the Blue Starlite, my twenty-car drive-in movie theater. I flipped the power switch and the lights illuminated around the little back-alley drive-in, turning the dark East Side lot into the tiny cinematic wonderland I had described to him. Charles was thrilled. I switched on the projector and the vintage drive-in movie ads started playing on the wall that I had painted with a fairly authentic-looking drive-in movie screen. We just sat there until he had to leave, talking about movies and how he'd always dreamed of having his own movie theater. In retrospect, it really was the perfect start to this project. I discovered later during my research for the book that Georges Méliès had one of the first outdoor movie theater spaces in Paris, back before the great movie palaces sprang up and left him and his work in their shadows.

Charles loves movies, movie theaters, and music, and man, does he love France. So in many ways *The Good Inn* is the ultimate love letter to all of the things that fascinate him.

So how did it become a book? Following a few of our "brainstorming sessions," I called up Steven Appleby, who did the very cool rocket drawings for the cover of the Pixies' fifth album, and I asked him if he would do some illustrations to help us with our

movie pitch. How cool would it be, I thought, to have the illustrator for *Trompe Le Monde* storyboard our movie! Appleby jumped on board and began drawing away, and Charles loved every panel he created. That's when the idea of an illustrated novel based on our screenplay idea came about. And thus, the book you hold in your hands came to be.

Over the next year, we delved deeper into the history books to find out anything and everything we could about *The Good Inn* and the men who first got their hands on a moving-picture camera. We wanted to know how these very early "blue movies" were made. As you can imagine, they were not considered national treasures or important French history. Many of them, including *The Good Inn*, were lost in time except for a few film frames.

One thing that seemed to happen frequently was that popular early pornographic films were remade and then renamed, to the point where it was nearly impossible to track down their origins. There are actually a few versions of *The Good Inn* that are described on the web, but the only moving images we uncovered were from a remake. This is available to watch online. The one still image that we were able to find depicted what we believe was the style and feel of the original film. As Charles describes this image, "It is strangely innocent, the actors don't seem self-assured in the least, they almost look like deer in headlights, they are not acting, it's almost as if it is real." The remake depicts a "musketeer" and is full of lighthearted sexual innuendos. This is more in line with later pornographic films, which would have been far more assured of themselves than, say, the first narrative pornographic film ever shot. This was an exciting discovery, but also frustrating, as we were hoping to see the original film that we were creating an entire world around. So I switched gears to try to find as many books about the first pornographic filmmakers as I could. I quickly discovered that there were none. Another setback for sure, so I decided to concentrate on learning

everything I could about the "legitimate" filmmakers of this time (1882–1915) and to see whether within their stories there were any hints or clues about the peers who might have made *The Good Inn* and other movies like it. And that's exactly where I found them, hidden in the paragraphs of other people's stories. So I told Charles my discovery, and soon he was sending me articles and biographies of French actors, artists, terrorists, politicians, producers, and directors that at some point or another had crossed paths with the same strange lost (or buried) names who in part created the first blue movies.

As a result of all of this detective work, many of the events that take place in *The Good Inn* are culled from real events in history. A number of actual people were also used as templates for characters, such as our antagonist Léar, whose history in film and on the planet is fairly well documented up until the early 1900s, when all mentions of him mysteriously come to a halt, as if he just vanished, or was erased, in time. Based on historical research, we interpolated to the best of our ability the most likely scenarios for what we felt would or could have happened.

Similarly, while many of the linking narrative elements are clearly inventions of creative interpretation and made up to tell the story that we wanted to tell, they are based on actual historical truths, such as our female protagonist Nickie Willy, who is in part based on Louise Willy, a performer in the peep show *Le coucher de la mariée*, as well as Louise Weber, a cancan dancer at the Moulin Rouge and a muse of the *affichistes* of Paris. As well, we made occasional historical guesses and mixed science fact with a shot or two of science fiction, and after two years, we had completed the narrative. When people asked me what it was like, I described it as the *Gone with the Wind* of French cinema's blue movie history if it was written by the Pixies and directed by David Lynch and Terry Gilliam.

Above all else, Charles is a storyteller. Not just a storyteller

but a collector of stories, a real honest-to-goodness modern-day troubadour, wandering through this dimension collecting the oddest oddball stories and turning them into rock 'n' roll. I grew up listening to his two-to-three-minute musical tales, surrounded tightly by clustered atoms of quiet cool to loud choruses, of entire worlds that left my friends' imaginations, as well as my own, spinning with images of aliens on lonely highways. There were proud Spanish dancers in seedy bars, monkeys going to the eternal kingdom, and biblical bloodbaths that somehow seemed sexy.

I always wondered what this man would do if he had more than three minutes to tell a story, and through our collaboration, now I know.

Charles did end up writing amazing new Pixies material. Released in parts over 2013 and 2014, a few of the songs' hooks were actually repurposed from instrumentals from the original recording sessions for the *Good Inn* demo that Charles, Joey, and David created together. Seven of the *Good Inn Demo Songs* lyrics were used as inspiration for this book and are "musical scene centerpieces" in the narrative.

What follows is an illustrated novel, based on an in-the-works soundtrack, for a feature-length film that has yet to be made, about the first narrative pornographic movie ever made.

And now, without further ado, let's dim the lights in the theater. We are very proud to present to you our film, *The Good Inn*.

DIAGRAM OF OVERLAPPING WORLDS

THE PHYSICAL WORLD
(HERE & NOW)

MY WORLD

MOVING PICTURES:
THE WORLD OF
PROJECTED LIGHT

love

THE WORLD OF
THE BOOK YOU HOLD
IN YOUR HANDS

YOUR WORLD

THE WORLD OF
MUSIC & SONG

IMAGINARY WORLDS

the Future

SOLDIER BOY'S WORLD

The
GOOD
INN

Prologue

A n old navy training film scratches its way to life in black and white. A gruff, middle-aged OFFICER appears, his thinning hairline and tight face positioned directly toward the camera as he commences his lecture.

OFFICER: We are now going to demonstrate the safe use and storage of nitrocellulose, also known as guncotton. This compound is extremely volatile, which is why it is primarily used as an explosive material in weaponry. Notably, it is also used as a film base for the new moving picture industry. Be aware that this type of material should ALWAYS be stored with extreme care as it is highly flammable and can cause severe bodily harm.

To prove his point the officer strikes a long match to light the film reel on fire and drops it into a large transparent container. The reel flares up and explodes with a white-hot flash as the chemicals in the emulsion feed off the air and flame. It continues to emit noxious flames and smoke as he continues . . .

OFFICER: This chemical reaction also produces deadly fumes that will kill you. If you find yourself in close proximity to nitrocellulose-based materials and intense heat or flames, we can only recommend that you . . .

RUN LIKE HELL!

The reel ends, blasting the screen an unearthly white as the film flap-flap-flaps lazily against the back of a humming projector.

Pigalle District,
Paris, 1929

INTERIOR/PROJECTOR BOOTH/NIGHT (in black and white)

The ancient film projector sits in a graying projection booth that has clearly seen better days. Tattered movie posters are clinging desperately to the walls and stacks of old film reels balance on top of one another. An old man's shaky hands extract the navy training film from the dusty sprockets of the projection wheel and he flips the off switch as his young projectionist protégé watches.

OLD PROJECTIONIST: It is a lonely dead man's profession with an uncertain future. If I were you, I'd join the navy. At least it has a slightly better death rate than sitting in this perch.

The old man hobbles away, shutting the door and causing the thin walls to rattle. The young man's face follows a dusty reel as it falls off and makes its way toward the ground from the now-broken shelf on the wall. He picks it up and studies it. Across the cover, in faded script, the label reads, "WARNING! Nitrate Film: Highly Combustible." The boy opens the canister, threads the film into the projector, and proceeds to flip the switch.

Click, click, click. The projection lights burst bright with a blinding white explosion and . . .

(Angelic otherworldly voice singing over the white):

A bird, he sang a little song, I sang along.
It's from a film about an inn, that she was in,
And as with life there was a plot, but
not a lot.

Get to the chorus, she's waiting there for us,
This is just the chorus, and we're just the
choral ode.

Paris 1889

la bonne auberge

EXTERIOR/PARIS/DAY (in color)

Across the dark, quiet countryside and over a sloping hill, thousands of twinkling lights blanket the horizon, causing the city to glow as though it is slowly being engulfed by low, warm flames. A newly built magnificent metal tower attempts to touch the sky, rising from the furnace below, dwarfing the cobbled streets and outdoor cafés. This is Eiffel's tower. This is

Paris...

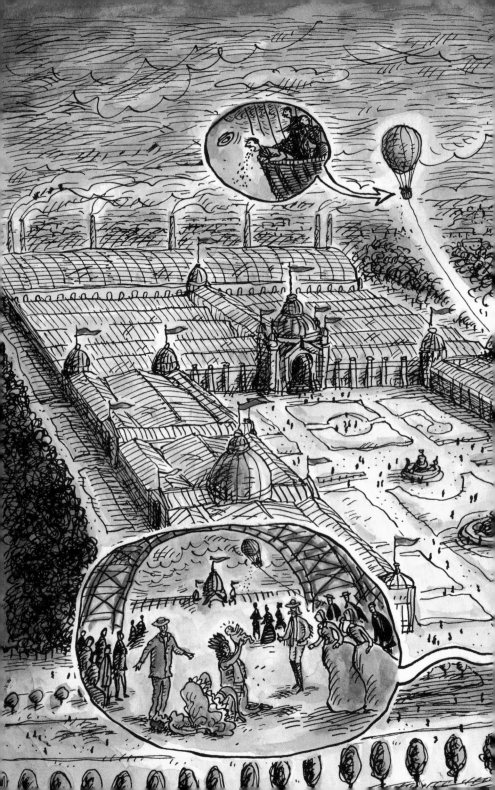

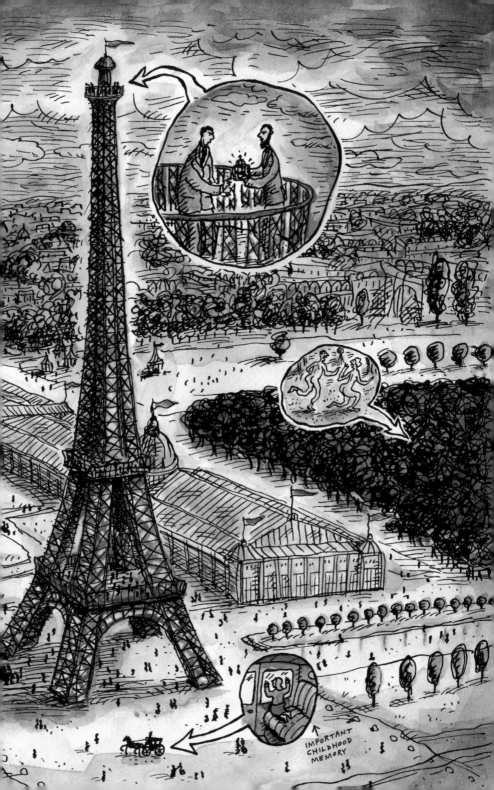

IMPORTANT
CHILDHOOD
MEMORY

SOLDIER BOY (voice over image): When I was
young, I was told my mother was very pretty
and my father was very slow. I was born on
May 10, 1889 at the Exposition Universelle.

EXTERIOR/WORLD'S FAIR/NIGHT (in color)

Chaos is unfolding right below the Eiffel Tower's giant iron legs.
Dozens of onlookers gather around a woman, who is moments away
from giving birth. Her blond hair splays out around her fragile,
contorted face. A small, thin man hyperventilates as he looks down
at his wife, her legs spread, screaming at him to do something,
anything.

SOLDIER BOY (voice over image): There wasn't
enough time to fetch a doctor, so a medicine
man from Buffalo Bill's Western Show stepped in.

A statuesque man in a cowboy hat, with pistols at his hips, pushes
the husband aside to assess the situation. Buffalo Bill's long white
whiskers are perfectly greased into two symmetrical curls. He grunts
and briefly steps away, returning with an old Native American in an
authentic feathered headdress who begins the work of delivering the
baby.

The healer's glassy black eyes focus, in concentration, as he
hums a deep, resonant song to bring the baby into this world. The
husband watches fretfully, his sweating face inching closer and
closer. CHEERS! A scream! MORE CHEERS!

The medicine man's forehead creases in concern as he cradles the
wet newborn in his hands. He whispers a multitude of unintelligible
words to the crying infant before presenting it to the crowd, which
erupts into cheers. All of the women gasp in adoration as the mother
extends her wiry arms out for her child.

The shocked husband smiles a lopsided smile in relief. Buffalo Bill reaches into his pocket to reveal a finely rolled cigar, which he sticks in between the husband's small, thin lips and lights. Buffalo Bill gives him a congratulatory slap on the back so hard the cigar is propelled onto the street in front of him.

SOLDIER BOY (voice over image): So many
promises were made on the day of my birth,
from flying cars to houses on wheels. A young
man from the States named Edison made sound
come out of a spinning cylinder, promising
everyone present, including my parents,
that he would soon make sound come out of
pictures. On the same night, Edison would
stand on the top of Eiffel's tower and shake
hands for the first time with Monsieur Emile
Reynaud.

Above the chaotic scene, which now has collected many curious onlookers, Eiffel's tower looms. The newborn baby peers up toward the sky as another scene is unfolding at the top of the tower. A small group of well-dressed men are gleaming down at all of Paris.

SOLDIER BOY (voice over image): Monsieur
Reynaud invented a little machine called the
praxinoscope (successor to the zoetrope),
which was a strip of pictures placed around
the inner surface of a cylinder that when
spun created the illusion of movement
through light on a curtain. Edison returned
to the Americas and immediately embarked on
the realization of the kinetoscope. He hoped
to add moving pictures to the sound of his
phonograph, effectively stealing Reynaud's
progress and simultaneously rendering it
obsolete. I imagined them almost as strange

angels looking down at me from the sky,
as they were, standing above the clouds,
hovering over Paris, on the brightest night
this city of light has ever seen. The whole
world anxiously waited at Paris's doorstep,
and imaginations were salivating with
anticipation at the thought of previous
impossibilities coming true—anything
impossible suddenly seemed possible. Most of
these promises never would come true, not
in my lifetime anyway, but a few of these
amazing promises . . . did.

 CUT TO BLACK

HOW MEMORY WORKS:

ACT I: Guncotton

You have to begin to lose your memory, if only
in bits and pieces, to realize that memory is what
makes our lives. Life without memory is no life at
all, just as an intelligence without the possibility
of expression is not really an intelligence. Our
memory is our coherence, our reason, our feeling,
even our action. Without it, we are nothing.

—LUIS BUÑUEL

The Guncotton Investigation

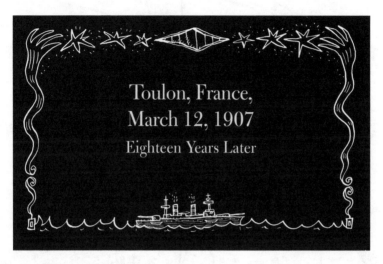

Toulon, France,
March 12, 1907
Eighteen Years Later

EXTERIOR/TOULON SHIPYARD/DUSK (in color)

The afternoon sun sparkles off of the beautiful Mediterranean seaport of Toulon. A lanky soldier, in the springtime of his life, with closely cropped dark brown hair, stands next to his square-shouldered superior, side by side with him. The more innocent and fresher of the two is called SOLDIER BOY. Whether his peers began calling him this to be cruel or as a term of endearment is no longer pondered by his fellow soldiers, his commander, or even himself.

SOLDIER BOY (voice over image): Eighteen years on and today is the last day I will be sharing a post with my friend and commanding officer, Roussou. To celebrate his retirement, Roussou thinks we should find *les putains* after our watch, but he is just being nice.

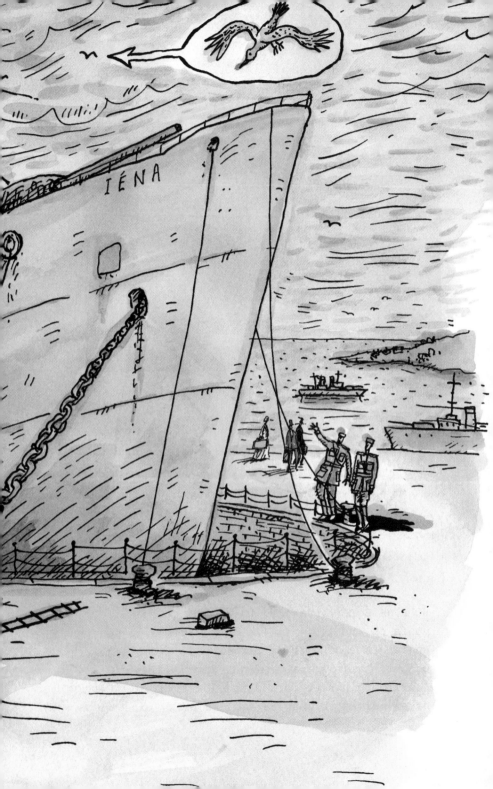

The girls always find Roussou first.

ROUSSOU, a glorious soldier with guts to match, gives Soldier Boy a strong pat on the back as they stand on an empty pier beside the *Iéna,* the giant warship that they are charged with watching over. The metal hull glints against the ocean, reflecting its deep blue sparkle.

ROUSSOU: She is magnificent, isn't she?

The two stand in awe in the most serene moment imaginable for navy men.

ROUSSOU: I have a small gift for you on this special day.

SOLDIER BOY: A gift for me? But it is your day, Roussou!?

ROUSSOU: I know how you appreciate little trinkets like these. Something to remember me when I am gone.

Roussou holds up a small, round device, the inside of which contains pictures on a wheel that lines the sides. Each image appears slightly different from the next. Roussou spins the wheel inside and the images come to life, creating a continuous motion.

SOLDIER BOY (excitedly taking it): It's a zoetrope!

ROUSSOU: If you say so.

SOLDIER BOY: It means "wheel of life." This was the precursor of the praxinoscope, which is the machine that first turned pictures into light!

ROUSSOU: It amazes me sometimes, how little you say, and yet when you do, how much it sounds like you know.

SOLDIER BOY: My aunt took me to see a show called *Le Théâtre Optique* at the Musée Grévin in Paris when I was very young. It was the most wonderful thing you could ever imagine. A moving picture conjured by light. It was as if all the lights of Paris had been harnessed and sent through this little hole, turning light into life. On display were these little machines that inspired its inventor's creation. I haven't seen one of these since then.

ROUSSOU: I won it off a trader from the Far East. He seemed quite upset to have to give it up, but I had to have it for you. These little pictures are the one thing that always seem to get you excited.

SOLDIER BOY: Thank you, Roussou. It is a wonderful gift. Did you know that Edison—

His words are interrupted by a harsh white light that blasts onto Soldier Boy, pushing his face and hair strangely backward, as if by an explosion.

CUT TO:

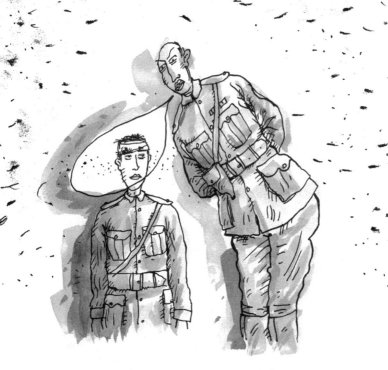

INTERIOR/INTERROGATION ROOM/NIGHT
(in black and white)

Sitting on one side of a metal table is NAVY MINISTER GASTON THOMSON. On the other side is a very dazed, banged-up, and distracted Soldier Boy.

GASTON: Shall we begin again?

SOLDIER BOY: Fine. Yes.

GASTON: You were about to explain the events of . . .

SOLDIER BOY: I can't quite remember. What is there to explain?

Soldier Boy touches his head, feeling a tightly wound bandage for the first time. Blood has seeped through it.

SOLDIER BOY: Why am I wearing this
ridiculous hat? It seems to be leaking.

Gaston sighs disparagingly as he turns to recounting the facts that Soldier Boy should already know.

FADE INTO:
EXTERIOR/TOULON SHIPYARD/NIGHT (in color)

(As Gaston recounts the details we witness the
entire sequence unfold.)

All is quiet on the harbor. Roussou and Soldier Boy stumble down the dockside, each holding the other upright, clearly returning from a night of celebration. All around them, lights flicker and bob up and down on the dark waters from dozens of boats docked around the bay. It is so very serene. They laugh as they continue their feeble attempts at holding each other up and walk forward at the same time.

GASTON (voice over image): On March 12, the
Iéna was dry-docked at Toulon's Missiessy
Basin for hull maintenance. A series of
explosions began in Iéna's port-number-five
one-hundred-millimeter magazine, which began
at one thirty-five a.m. and continued until a
quarter past two.

Suddenly, a small explosion can be heard from inside the Iéna. Then another. Then ten, or a hundred more, maybe even thousands, all in rapid succession like the popping of monstrous angry champagne corks. And then, much like the finale of an epic fireworks display . . .

BOOM! The sky lights up, and a massive force sends out a shock wave so strong that it knocks the two soldiers to the ground and illuminates the harbor in an apocalyptic daylight glow.

The *Iéna* begins to shred herself apart, her bow tilting forward toward Soldier Boy in salute.

Roussou jumps to his feet and shouts out to Soldier Boy, who has gone momentarily deaf from the sound of the blast. All he can make out is Roussou pointing to another ship down the dock, and then pointing to giant floodgates that hold the *Iéna* at bay, protecting it from what are now lifesaving waters.

GASTON (voice over image): It was then that De Vaisseau Roussou ordered you to deliver a message to the commanding officer of the *Patrie*, water-docked some fifty yards away. The idea was to fire a shell into the dry-dock gate, releasing the water to battle the flames but, due to either your incompetence or bad aim, it failed to properly land on its mark.

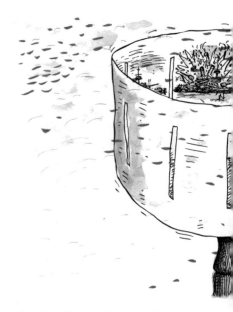

As the fire burns out of control, human bodies fall from the ship in flames, attempting to land in the nearby water. Some succeed, while others do not. Soldier Boy stumbles forward toward the nearby ship, shouting up to its captain, trying to hear his own words over the ringing in his ears.

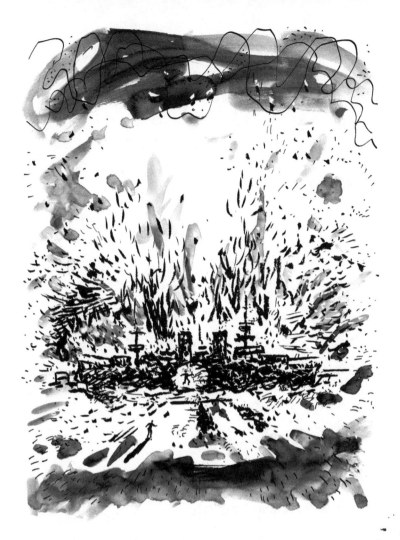

GASTON (voice over image): Roussou managed
to release the gates by hand and then ran
into the fire to rescue his men.

As the water gushes through the floodgates, Roussou runs past a
dazed Soldier Boy into the fiery hole in one side of the *Iéna*.
 Another *gigantic* explosion and the sky turns to day. Soldier Boy
looks up, mesmerized, into the white that blankets the sky.

SOLDIER BOY: Ah, Paris!

The water builds into a furious, towering flood that washes over the side of the *Iéna,* snuffing out its flames. It then recedes backward, into a wall of water that bursts onto Soldier Boy while carrying the charred debris of the Iéna, bodies, and, finally, the memory of the moment. Once the water recedes again we return to . . .

INTERIOR/INTERROGATION ROOM/SAME
(in black and white)

Gaston slams his fist against the table in order to regain Soldier Boy's attention, which has turned to a small hole in the distant wall. Light from the adjoining room is traveling through it.

GASTON: In total one hundred and seventeen soldiers, including two civilians, died.

SOLDIER BOY: Roussou is gone?

GASTON: Mostly, yes.

SOLDIER BOY: Mostly?

GASTON: Yes.

SOLDIER BOY: And the others?

GASTON: Personally, I'd be more concerned with what is to become of you. What should we do with you, Soldier Boy?

SOLDIER BOY: Me? I didn't do anything.

GASTON: *Non, bien sûr que non.* Someone's
going to take the fire for this. You would
prefer it to be me?

Frustrated, Soldier Boy presses his fingertips against his temples
in an attempt to replay the preceding events in his mind.

 CUT TO:

EXTERIOR/TOULON SHIPYARD/DUSK (in color)

Soldier Boy stands together with Roussou again, watching the vivid
sunset as the water sparkles on all sides.

GASTON (voice over image): You've heard of
nitrocellulose-based Powder B in training,
of course. Guncotton? Almost eighty percent
of the *Iéna*'s magazines contained it.

A BLAST! Everything around Soldier Boy disappears. He and
Roussou are standing on the deck of the ship, but there is no ship. It
has been entirely replaced by whiteness.

SOLDIER BOY: Where did the ship go?

ROUSSOU: Blown to bits!

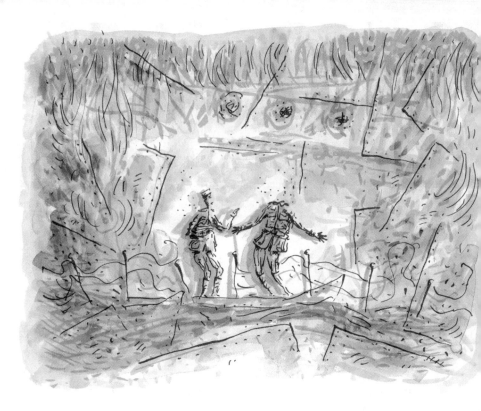

Soldier Boy turns to Roussou, whose head has vanished, only to be blotted out and replaced with a white HOLE. In the hole are moving scratches, like the end of an old film reel running through the projector's light.

SOLDIER BOY: Where did your head go?

ROUSSOU: Lord! Blown through the roof!

The hole making up Roussou's head begins to expand, engulfing Soldier Boy and everything else around him.

 CUT TO:

INTERIOR/INTERROGATION ROOM/DAY (in black and white)

INTERIOR/INTERROGATION ROOM/DAY (in black and white)

Soldier Boy sits, slumped in another cold, nondescript concrete room, or possibly the same one as before. A softer, almost sympathetic official taps his foot, bringing Soldier Boy out of his daze. The official's uniform is slightly disheveled and a patch of food stains his collar.

LIEUTENANT LOUISE: Don't look so glum. The rest of the survivors are being dispersed as well. It's not just you. Actually, consider yourself special.

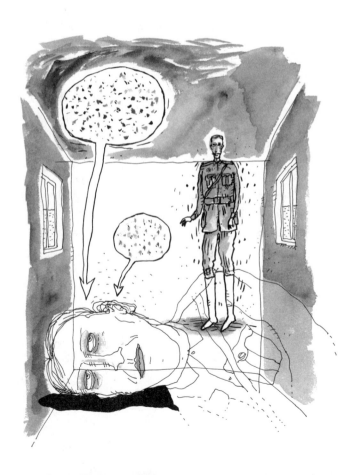

SOLDIER BOY: Special?

LIEUTENANT LOUISE: Sure, special . . .
You were almost killed! A terrible blast,
kaboom! A deathly light came for you and it
meant to destroy you. It meant to feed off of
you so that it might burn brighter, but you
escaped it!

SOLDIER BOY: I escaped the light?

LIEUTENANT LOUISE: You have been given
a freedom the others can't enjoy. Their
reassignments are permanent stations. *You*
can go where you please. Look at it as if
you are on a special mission.

SOLDIER BOY: A special mission to . . . ?

Lieutenant Louise gives Soldier Boy an uncomfortable look as he
shifts his weight from one foot to the other, devising a decent way to
cut the conversation short.

LIEUTENANT LOUISE: Look, Soldier Boy, go to
Paris. See a show. Find a nice girl and have
her, or don't have her. Maybe she won't be
pretty enough for you? *Ce n'est pas grave.*

← The
 Past

THIS PAGE—
The Present

SOLDIER BOY: Who will I be reporting to?

LIEUTENANT LOUISE: All in good time.

Soldier Boy places his heavy head down onto the table. A driving force pounds against the back of his eyelids, making him feel nauseated. He grinds his teeth, forcing himself to sort through his thoughts. He looks up pleadingly to Lieutenant Louise.

SOLDIER BOY: You're just a blur. I am having trouble remembering why I am even sitting here in front of you. If I wanted to, it feels like I could make you disappear completely.

The lieutenant closes his dossier and looks up at Soldier Boy with empathy.

LIEUTENANT LOUISE: Perhaps, my friend, that would be best.

The lieutenant begins to rapidly twitch and blur out of focus. Darkness blows out from his center and transforms into a hollow tunnel. Out of the tunnel, a train pushes through, steam lubricating it, and comes to a stop at a dark station. Above, the sky is a starless black.

The
Future →

A MAP

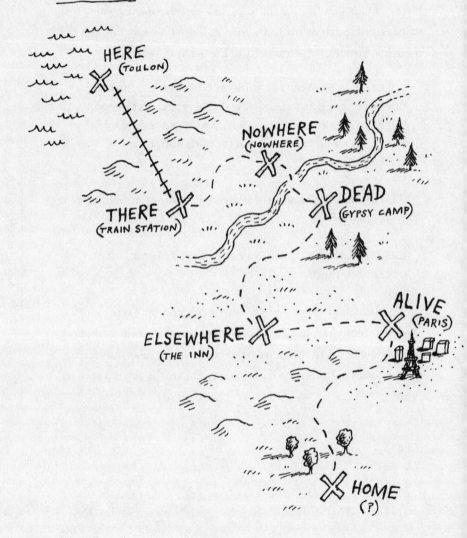

Wandering

The explosion of the *Iéna* in the suburb of Pont du Las triggered what came to be known as "the Gunpowder Scandal." With casualties of over one hundred soldiers, Navy Minister Gaston Thomson ordered the surviving servicemen to be honorably discharged. One soldier, however, received different orders: only Soldier Boy had seen what had actually occurred on the dock in Toulon, and Minister Thomson did not want him appearing before any inquiry board. Many people had just died, and someone was going to have to be responsible. Despite Gaston Thomson's best efforts, he was eventually forced to resign and Soldier Boy nearly missed his train.

EXTERIOR/TRAIN STATION/NIGHT (in black and white)

Soldier Boy runs to catch the train as it huffs, puffs, and blows off steam.

Soldier boy sits alone in a train car. The night is so dark that nothing can be seen through the windows. It's almost as if the car isn't even moving in time.

A CONDUCTOR walks through the car, shouting out announcements, oblivious to the lack of seated bodies on the train.

CONDUCTOR: Next stop in fifteen minutes, and then nothing for a while. It's dark outside, so there is nothing to see. Good time to sleep. Good time to dream.

The train car SCREECHES without impact, but Soldier Boy is thrust to the side as if it has.

CONDUCTOR (shouting again to the empty car): We just turned into the mountainside and are hugging it now. We will be for some time, until we aren't anymore.

The Conductor checks his watch and walks out of the car, and in through the other end.

Soldier Boy looks out the window into the blackness.

A voice behind Soldier Boy speaks. Soldier Boy, entranced by the black hole outside the window, stares into it deeply, getting lost and swallowed up in it. He passively listens while a man in the row opposite him looks out his own window.

MAN WITH THE BRIEFCASE: They say that everything moves forward due to momentum. Once you've gained speed, you can't help but move forward. Some say that a train like this one does just that. Others believe in a theory based less on gravity and more on evolution. Have you heard of the theory of

relativity? It is the latest thing, or at least it will be. Others say that time and space move forward with leaps and bounds due to cataclysmic events completely out of our control. Do you see?

SOLDIER BOY (turning to the man): Are you speaking to me?

MAN WITH THE BRIEFCASE (turning to Soldier Boy): I don't know. Maybe. Could be. It's not impossible. I wouldn't be surprised. I speak to myself and hope that others will listen. Sometimes, though, I wonder if what I think out loud would be better left unheard.

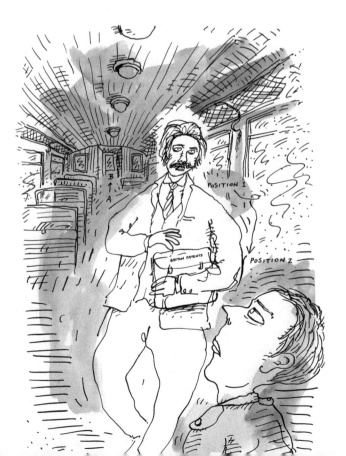

SOLDIER BOY: I don't really understand, I guess.

MAN WITH THE BRIEFCASE: This train moves by momentum, only possible because of gravity, but begins to move by a small combustion inside the belly of this beast, that WE IGNITE. It moves because we make it move, but it wouldn't move if the elements did not allow it to. Do you see?

SOLDIER BOY: I guess. Are you headed to Paris?

MAN WITH THE BRIEFCASE: No. Why would you think this?

SOLDIER BOY: That's the direction the train is heading.

MAN WITH THE BRIEFCASE: Ah, yes it is. At this moment. I'm going to a conference in Toulon to present my latest theory.

SOLDIER BOY: But that is the other direction.

MAN WITH THE BRIEFCASE: For now, but that could change. Do you see?

Soldier Boy returns to looking out his window.

From the center of Soldier Boy's black abyss, the window fills with words, like in a silent film. It appears to read: "GASP!"

The man now stands over him, looking down on him quite intensely yet patiently. Soldier Boy turns to look up at the man; his eyes first pass over the label on his briefcase: "Gaston Patents."

As Soldier Boy looks up at the oddly friendly and warm face of the man, the train SCREECHES around another bend and the man topples over, and as he does so, he cries out . . .

MAN WITH THE BRIEFCASE:

GASP!

On cue, the Conductor rushes through the car again, stepping over the fallen man and out the door toward the opposite end of the car while shouting.

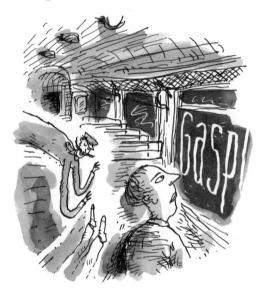

CONDUCTOR: Another screech, another bend, around we go, watch your step, watch your footing, a standing passenger has fallen over in car two! Whoopsie daisy!

The train is dead silent and motionless once again. Soldier Boy stands and offers his hand to the fallen man. As Soldier Boy tries to help the man up, the man panics and swats at the air in front of Soldier Boy. The man is acting almost as if he is blind.

MAN WITH THE BRIEFCASE: It is highly
probable that YOU are going against the
very fabric of time and space. Have you
considered this? It is a practice that is
not very wise.

He pushes in closer, staring right through Soldier Boy, mere inches from his face. Soldier Boy is both entranced and frightened.

MAN WITH THE BRIEFCASE: The elements are not
fond of being abused, they can get angry and
do horrible things. Men believe they have
tamed light, but they will never be able to
outrun it. Do you see, Soldier Boy? In the
end we are all prisoners of time and light.
You can travel in any direction you please,
but where there is no light, there is only
death.

The man hurriedly grabs his briefcase up from where it fell, hugs it, and backs out of the train car, leaving Soldier Boy alone in the car again.

Soldier Boy sits back down and looks out the black window. The black is replaced by a train station scene, as if a slide has changed.

The Conductor blasts into the car and walks up to Soldier Boy, bends down, and yells into his ear.

CONDUCTOR: We have stopped. This is your
station! The next station stop isn't for you!

The Conductor rushes back out of the car. Soldier Boy stands up and walks out of the train car, onto the platform.

EXTERIOR/TRAIN STATION/NIGHT

The train hisses and steams. A soot-filled mist covers the ground.

Soldier Boy wanders up to the engine and looks to find no one inside. In fact, there is no one anywhere. The train has stopped and the station is now dead silent.

A whistle sounds and the train groans to life as it begins to back up out of the station. Soldier Boy walks onto the tracks and watches as it disappears backward into blackness.

He turns and looks down the empty tracks ahead and walks forward, following them into the night.

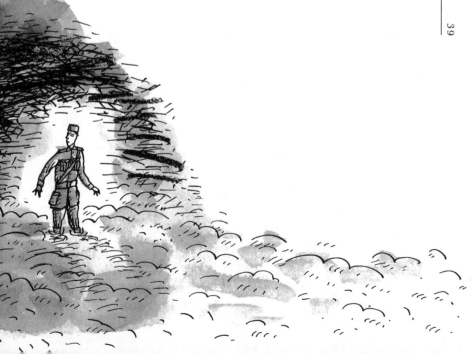

Soldier Boy walks along the tracks, looking down and watching each plank. It's hypnotizing, and the only thing to see.

He watches with curiosity as the planks grow fewer and farther between. Soon there are just tracks on either side, and eventually no tracks at all. Soldier Boy stops, realizing there is nothing at all to look at, nothing to mark his path, and nothing at all but the dark.

The sound of rushing water overwhelms Soldier Boy's eardrums. He covers his ears to mute the crushing sound. He stumbles through the dark until he arrives at a large river that cuts through the blackness.

Black Francis and Josh Frank

In the water's reflection is a lush forest lit by moonlight. As he looks up from it, the image of the forest in the water reflects onto the black world, replacing the black with a moonlit forest that now surrounds him on all sides.

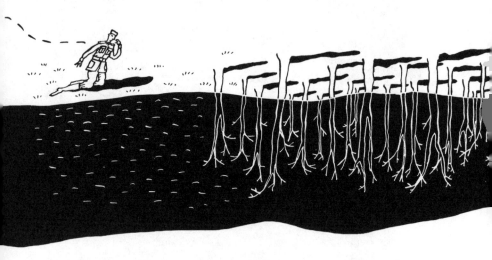

As Soldier Boy walks along the river, listening to its soothing sounds, the wooden mechanism of wheels on a cart comes clanking up from behind him. A horse snorts as its hot breath hits Soldier Boy's neck from above. He turns to look up at it.

A PEASANT is driving a horse-drawn cart alongside him.

PEASANT: Need a lift, Soldier Boy?

SOLDIER BOY: Where are you going?

PEASANT: No, not a ride. A lift!

The Peasant bangs on the side of his cart and it slides open to reveal an impressive pop-up storefront. A sign above the many bottles, cans, and oddities reads:

Pierre's Portable Potions and Poetry

He hops down from his seat and presents his wares theatrically. Although dirty, dusty, and derelict, the man certainly does have showmanship.

PEASANT: You look like you could use a pick-me-up! I have all kinds that are sure to get you where you are going. Something to put a spring in your step and a smile on your face. Protection from enemies, gifts for friends, naked women that you can carry around in your pocket! Every purchase comes with a message, words designed to inspire and elevate. [silence] Feel free to browse.

The Peasant withdraws into the background as Soldier Boy cautiously steps forward and looks at the impressive collection of bottles in all shapes and sizes. One of the bottles stands out to Soldier Boy. Unlike all of the others, it is not dirty, dusty, fogged, or mildewed. It seems to be illuminated from within. A label on its side reads:

Le fabricant d'ange

(The Angel Maker)

SOLDIER BOY (pointing to the bottle):
I'll take that one.

As Soldier Boy ruffles through his small change purse, which is attached to his uniform, the Peasant shakes his head violently.

PEASANT: That's not what you need. No, no, no. How about this one? This one is sure to quicken your step and harden your head!

He holds up an ugly little bottle full of something gray and oily.

SOLDIER BOY: No, I am sure that I want that one. How much for it?

PEASANT: That one's not for sale, Soldier Boy.

SOLDIER BOY: In that case, why is it here?

PEASANT: It's my peacock. It's here to pull the customers into the shop. I can't sell it because then I'd have no peacock! [pause] If you're not going to buy anything, I guess I'll be on my way.

The Peasant turns to get back on his cart.

But then he pauses, steps back, turns to Soldier Boy, looks him over as if he is considering if he is worth the time it would take to share the secret he is about to confide in him. The Peasant digs into his coat pocket and turns back toward Soldier Boy.

PEASANT: Are you perhaps interested in some visual entertainment instead? It is sure to amuse, entertain, dazzle, and relieve.

He flashes a handful of picture cards out in front of Soldier Boy. They each depict a different naked woman standing oddly, for what would seem like an otherwise normal portrait.

PEASANT: These are authentic originals from *Monsieur Pirou* himself!

Soldier Boy blushes. He can't help but stare.

SOLDIER BOY: What would I do with those?

PEASANT: A silver piece for one card, or

two silver pieces for three
cards! It will cost you extra
for instructions.

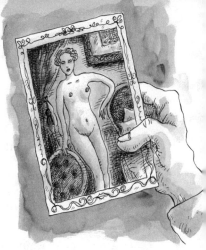

Soldier Boy hands him a piece of silver
and pulls the one he wants from the lot.

PEASANT: For that price, you
will just have to figure it out
on your own.

The Peasant grunts and hops back onto his
cart, pulling on the reins of his horse.

SOLDIER BOY: Could you at least give me a
ride to the nearest town?

PEASANT: I'm not going your way.

SOLDIER BOY: How do you know which way I am
going if I don't?

The Peasant clears his throat and takes a showmanly stance. His
harsh peasant voice transforms into a beautifully eloquent speaking
voice as he recites his prose.

PEASANT: "All the roads lead to the
city, like veins of the river Rhône lead
to deepest water. This road leads to the
brightest lights that could ever be, but she
won't be there. She's like water in a desert
sea."

And then, as if it were the period on the end of his prose, the
Peasant yells, "Yaaaah!" to his horse. Just like the train, they back
up into the night.

Before disappearing into darkness, he shouts after Soldier Boy.

PEASANT: There is an inn up ahead about
five miles. Just follow the river upstream,
Soldier Boy! You can't miss it. It's the only
friendly light in the night around these
parts. I promise you.

EXTERIOR/ROAD/SAME

Alone once again, Soldier Boy stares down at the picture he purchased. His finger covers the woman's nakedness and he stares deeply into her face. He walks through the mud along the riverbed and notices a campfire in the distance. He approaches it carefully and finds a Gypsy camp. It seems like it was abandoned in a hurry. The fire is still smoldering.

The brush rustles and Soldier Boy turns to see the back of a soldier dressed just like him. In fact, from behind, it could just as easily be him. Afraid, he backs up and falls over the fire and onto his back. The Soldier turns, brandishing his bayonet and sticking it into Soldier Boy's face.

Two other soldiers walk out of the woods and stare down at Soldier Boy. To his amazement, all three of the men look like one another. They are identical.

SOLDIER 1: What are you doing out here
creeping around in the woods, soldier? We
could have accidentally caused you bodily
harm.

SOLDIER 2: We might have.

SOLDIER 3: We still could.

SOLDIER 2: What's your name?

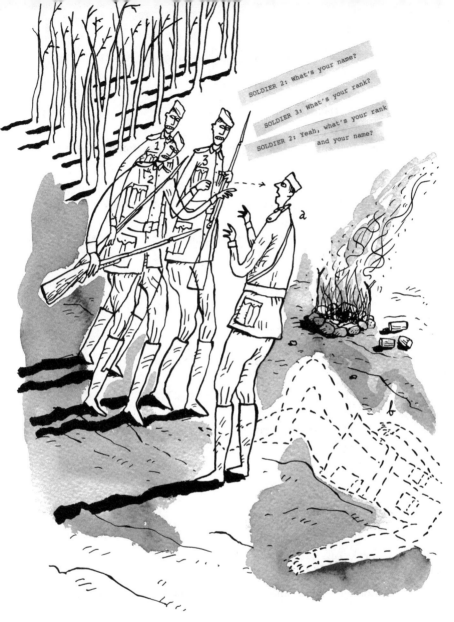

SOLDIER 3: What's your rank?

SOLDIER 2: Yeah, what's your rank and your name?

SOLDIER BOY: My name is Soldier Boy.

SOLDIER 2: Are you making a joke at us?

SOLDIER 1: Why don't you wear your rank on your arm, boy?

Soldier Boy stands silent, looking them over, not quite sure what to say.

SOLDIER BOY: I'm on a special mission.

SOLDIER 1: Special mission? What special mission?

SOLDIER 2: Maybe he's a spy?

SOLDIER 1: Are you a spy?

SOLDIER 3: If he's a spy, we can rough him up.

SOLDIER 2: How would we tell?

SOLDIER 3: We probably won't be able to tell until after we rough him up.

SOLDIER BOY: I'm not a spy.

SOLDIER 1: No, if he were a spy, he'd do a better job of blending in. He'd wear his rank on his arm.

Soldier 1 menacingly approaches Soldier Boy and they stand nose to nose.

SOLDIER 1: He's been thrown to the wolves. Something happened, something big, and they sent you as far away from it as they could.

Soldier 3 steps up and stands just behind Soldier 1's shoulder.

SOLDIER 1: So now you're here.

SOLDIER 3: Thrown to the wolves.

Soldier 3 swings back and his fist meets Soldier Boy's face.

THE WORLD GOES COMPLETELY WHITE, LIKE A PROJECTOR LOSING HOLD OF ITS FILM REEL, WHITE, SCRATCHY, and then BLACK.

EXTERIOR/GYPSY CAMP/HOURS LATER

It could have been days, for all Soldier Boy knows, but it was really just hours, not that it matters either way. What matters is that he is alive, it seems. He can feel his body, but he can't see anything.

THE BLACKNESS IS AGAIN REPLACED BY THAT SAME PROJECTOR WHITE. SCRATCHES AND A FILM REEL'S EDGE PUSH BACK INTO POSITION. BLACKNESS.

Soldier Boy opens his blood-encrusted eyes and a young GYPSY BOY is standing over him.

GYPSY BOY: Don't move or it will hurt more. They were going to kill you like they kill my people, but I stopped them.

Soldier Boy glances down to see the three soldiers. They are dead. It appears that this boy has brutally gutted them. He blacks out.

CUT TO BLACK

THE BLACKNESS IS AGAIN REPLACED BY THAT SAME BLINDING WHITE PROJECTOR LIGHT. SCRATCHES AND A FILM REEL'S EDGE PUSH THEMSELVES BACK INTO POSITION.

EXTERIOR/DIRT ROAD/NIGHT

Soldier Boy opens his eyes once again, but this time to a moving sky lined with trees.

He is lying flat out on a cart filled to the brim with hay. The young Gypsy is pulling a horse in front of it.

GYPSY BOY (talking with his back to Soldier Boy): In the Americas your people, the people in uniform, have this saying when they refer to their natives. They say that they are going the way of the Gypsies. We are now the old reference for a whole new bloody conquest. I feel sorry for them. We

can just move on, those of us who were not
murdered. That is what we do, and why we do.
We used to fill these woods. There were camps
all along the Rhône. No more. Now we join
the circus, or we join the dead. You are
like us in a way. This is why I saved you
from those savages. You are not a savage,
but you haven't decided whether you still
want to live amongst them. They can smell
this. They are just animals, like everything
else in these woods. Some animals' journeys
are longer than others'.

The horse and cart stop.

GYPSY BOY: Can you walk?

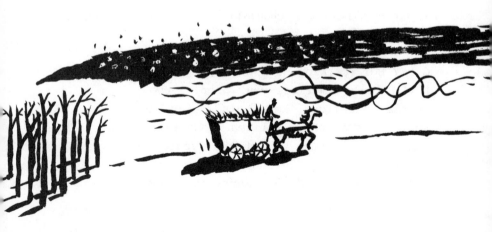

SOLDIER BOY: I think so.

GYPSY BOY: I can't take you any farther.
This is as far as I can go. There is a light
up ahead and this is now a friendly road.

The young Gypsy helps Soldier Boy stand up and Soldier Boy examines himself. Aside from the damage to his face, he seems to be okay. He looks inside his pouch and finds his coins still there, along with his picture card. As he turns to thank the boy, he sees him pushing the horse backward into the night, strangely reversing down the same road, as the others did.

They are gone. He is alone again save for a warm glowing light in the distance. He follows it through some brush and comes upon a quaint and inviting-looking inn. A warm fire crackles inside. For the first time, Soldier Boy realizes how cold he is.

THE GOOD INN

53

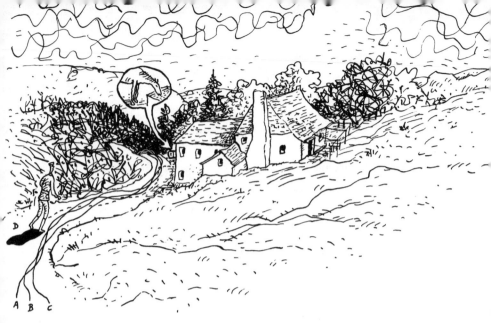

He steps into the light and sees his reflection in the window. His face is caked with blood and dirt. He walks over to the horse's trough. A tired and despondent horse stands over it and snorts as Soldier Boy approaches.

SOLDIER BOY: May I join you?

The horse appears to agree and backs up.

Soldier Boy ducks his head into the dirty water and throws his head back, choking from the cold shock. He goes back to the

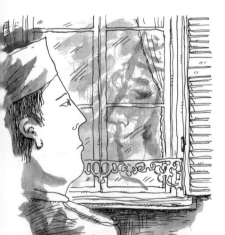

window, smooths his hair against his skull, and wipes away the remaining dirt and blood from his face with his coattail. Better. Presentable. It will do.

He is about to turn and head for the door when he catches a glimpse of her. She suddenly looks up and right at Soldier Boy, through the window. The window, as if on cue, fogs up and the front door BURSTS OPEN.

Standing at the doorway is the INNKEEPER with a welcoming smile. He is a small man with a large gut and short, fat arms that wave Soldier Boy into the warm light of the entry room. The smells of hot food and fresh perfumed sheets rush into his frozen nose.

INNKEEPER: A bed, yes? Food? We have them
both. A little more bed than food tonight,
but please, step under the Golden Shield,
into my Good Inn.

Above the Innkeeper is indeed a shield the color of gold. Its luster seems to have gone long ago.

Soldier Boy walks into the warmth and it swallows him as the door closes behind him.

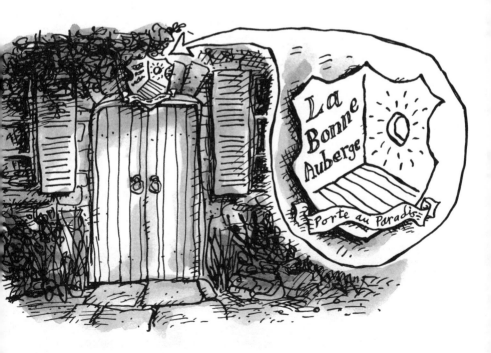

La Bonne Auberge

Porte au Paradis

HOW TIME WORKS

DIRECTION OF ROTATION

NOW

The Past

The PRESENT

Another Place

The FUTURE

The Collective Subconscious

?

Somewhere else

Time leaking away

ACT II:
The Good Inn

All my life I've been harassed by questions: Why
is something this way and not another? How do
you account for that? This rage to understand, to
fill in the blanks, only makes life more banal. If we
could only find the courage to leave our destiny
to chance, to accept the fundamental mystery of
our lives, then we might be closer to the sort of
happiness that comes with innocence.

—LUIS BUÑUEL

MAN READING
A NEWSPAPER
IN THIS
REALITY

IN ANOTHER
REALITY HE
CREATED
THIS ENTIR
WORLD

Under the Golden Shield
at the Good Inn

S oldier Boy follows the Innkeeper into a sitting room. Through a doorway to his left is the inn's tavern. A bar and doorway lead farther into the recesses of this rural setting toward a modest kitchen. To Soldier Boy's right is a rickety staircase leading up to the rooms. Candles flicker around him as he looks down to see a short, balding man sitting in a chair with his face obscured by a newspaper. The newspaper's front page catches Soldier Boy's attention, and he focuses in on it. The main picture is of his ship and the aftermath of the explosion. The caption reads:

118 dead from avoidable tragedy on *Iéna*

Below it is a smaller picture of a menacing man in profile. The caption reads:

Félix Fénéon Still at Large: Artist? Terrorist? Or Both?

The Innkeeper notices his new guest staring at the paper and nervously turns Soldier Boy toward the door to the tavern, ushering him in.

INTERIOR/GOOD INN TAVERN/NIGHT

There is a warm and modest room with five tables and a small wooden bar with a row of bottles in numerous shapes and sizes and colors.

INNKEEPER: Do not mind the professor, he does not lower news from his face for anyone.

SOLDIER BOY: The news. "One hundred eighteen dead."

INNKEEPER: Yes, yes—tragic. You must be hungry?

SOLDIER BOY: It was one hundred and seventeen, as I was told . . .

INNKEEPER: You must be tired.

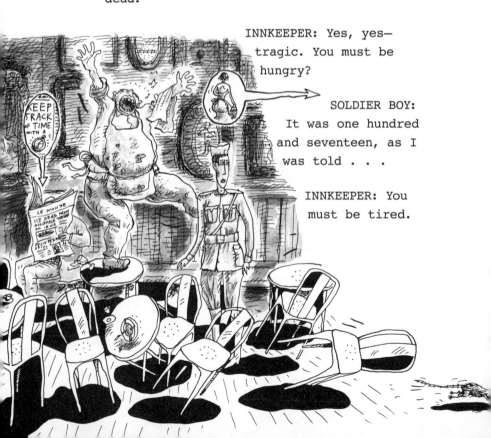

SOLDIER BOY: I am both tired and hungry.

The Innkeeper waddles over to a bench by a window looking out onto the black night. He pulls it out, dusts it off with his apron, and presents it to Soldier Boy, who politely sits. Out of the corner of his eye, he sees a silhouette through the doorway of the kitchen.

The silhouette is a woman's figure, and her curves are framed in the doorway for a split second before the Innkeeper blots out the image with the mass of his body.

INNKEEPER (singing to Soldier Boy
a cappella): *Have a meal now, Soldier Boy,
our beds are warm, our beds are warm.*

SOLDIER BOY: Are you singing?

The Innkeeper pours Soldier Boy a drink and then one for himself. He puts the glass in Soldier Boy's hand. Then, pulling the glasses together, he toasts them.

INNKEEPER (singing to Soldier Boy): *Have a
drink now, Soldier Boy, so we can sip to
limbs now destroyed!*

The Innkeeper tugs at his bad leg and Soldier Boy runs his fingers over the gash on his forehead. They both empty their glasses.

INNKEEPER (singing to Soldier Boy): *Your
money won't be better spent . . .*

As Soldier Boy pulls out his pouch of coins, the Innkeeper lovingly takes the pouch from Soldier Boy and empties a portion of its contents into his hand.

INTERIOR/KITCHEN/SAME

A woman's rough hands scrub the dirty kitchen floor.

WOMAN'S VOICE (singing): *Hands pay the rent, hands pay the rent.*

A large rat runs across her work and she continues scrubbing with one hand as her other scoops up the rat in one motion and shakes it so violently that its neck breaks. She continues scrubbing and humming the somber tune.

INTERIOR/TAVERN/SAME

INNKEEPER (singing): *Have a meal now, Soldier Boy. The bird is slain, the bird is slain.*

The Innkeeper thrusts a small plate of fowl and greens in front of him. He eats the small helping with a few swift jabs of his fork.

INNKEEPER (singing): *Now meet my daughter, she is my joy.*

The Innkeeper steps aside and the silhouette reappears in the doorway.

NICOLE, the Innkeeper's daughter, steps out into the warm light of the room shyly, right next to her father. He takes her by the chin and lifts it up gently.

INNKEEPER (singing): *I know, my daughter is heaven-sent.*

He takes her hands in his and caresses them.

INNKEEPER (singing): *But, hands pay the rent . . .*

He places a washcloth into her hands and signals her to scrub the
floor beneath their feet.

INNKEEPER: Hands pay the rent. I know what
you are wondering, so I will tell you . . .
[singing] *Her mother left when she was young,*
nary a soul speaks her name, nary a soul
speaks her name. And if they did, I'd cut
out their tongues. I don't remember where
she went, but hands pay the rent.

Soldier Boy leans down toward her, feeling embarrassed, dazed,
and strangely aroused.

SOLDIER BOY: You don't have to do that right
now . . .

The Innkeeper comes between them and bears down on
Soldier Boy.

INNKEEPER (singing): *And although I will feel*
like death in the morn, I still drink far
too much, I will drink far too much. I was
cock of the walk, before she was born. I'll
be listening for her descent. And although I
know she's heaven-sent, hands pay the rent.

The Innkeeper sticks his giant hand into Soldier Boy's coat
pocket and retrieves another piece of silver. He looks at his daughter
and disappears.

Nicole looks at Soldier Boy, who looks down at his cleared plate. He is still so very hungry.

```
SOLDIER BOY: Is there any more food to eat?
A second helping? Another course perhaps?

NICOLE: There is no more food to eat, I am
afraid. We have no more food tonight.

SOLDIER BOY: Your father took most of my
gold and all of my silver.

NICOLE: Should I show you to your room?

SOLDIER BOY: Who are you?

NICOLE: I am the Innkeeper's daughter, and
you are a lost, wandering soldier. What more
is there possibly to know?

SOLDIER BOY: What do you have then, if
nothing to eat? How will I sleep if I cannot
eat? What is my gold and silver worth if I
cannot even have a satisfying meal?

NICOLE: We have no more food, but I have
skin.
```

INTERIOR/SOLDIER BOY'S ROOM/NIGHT

In the moonlight, Nicole stands over Soldier Boy, who sits in a rickety chair. He watches her as she prepares his bed for him.

Her curves and delicate motions distort the shadows as they dance around the candlelight, projecting her body's true form through her dress on the walls surrounding him. This shadow theater lulls him to sleep and his eyes shut.

Nicole turns to Soldier Boy, who has fallen asleep. She cautiously approaches and runs her hand gently through his hair. She touches his face tenderly and curiously, lingering on every scratch and scar with her fingertips.

Walking toward the door, she blows out the candle, leaving the room in darkness as she closes the door behind her.

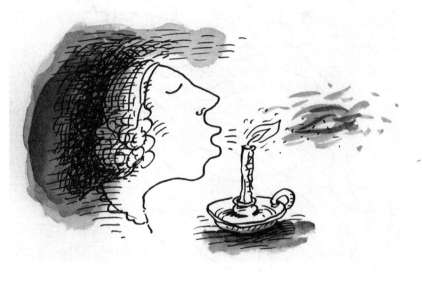

CUT TO:

EXTERIOR/*IÉNA*/NIGHT

Soldier Boy is running toward the flaming ship. There is a giant hole in the side. Screams, shouts, sirens, and smoke, and bodies everywhere. From inside the hole, a dark figure is running toward Soldier Boy. A flash, and for a split second, he sees Roussou. Then Roussou's body explodes. The hole implodes, and as Soldier Boy finally gets to it, it is no longer a giant hole but a very very small one the size of a bottle cap. Light is flickering in it. Soldier Boy steps up to it and looks in.

BANG! He flies into the air, into the night sky, into the stars, and then into nothing.

**Soldier Boy's
eyes open.** The
bed covers are soaked
and he is drenched
in cold sweat. The
room is quiet. Moonlight
shines from the small window beside his bed. Nicole is standing over
him, glowing. She holds fresh white sheets in her arms.

NICOLE: I'm sorry to disturb you. I've come
to make you more comfortable. You were
dreaming something horrible.

SOLDIER BOY: I'm sorry. I hope I didn't
scare anyone.

NICOLE: Who could you scare while
sleeping besides yourself? Do you
remember what you saw that caused
such sounds to wake the dead? It
helps to speak about the things that
only you can see. It is by telling
our stories that we can, for a short
time anyway, not be alone. Do you
want to tell me a story, Soldier Boy?

She gently pulls the soaked covers up from under him and then throws the new ones up into the air over him, covering him in the cool, soft sheets. It's like he is falling through a white, soft sky, and when he lands, Nicole is above him. On top of him. She undresses as he lies awkwardly under her, almost embarrassed by his powerlessness. He turns her over roughly and then with tender care takes her in his arms and falls softly into her breasts.

Soldier Boy begins to sing a cappella; he appears confused as to why he is doing so at first, but slowly, he gets used to it.

> SOLDIER BOY (singing): *I was on* Iéna *working for poor Roussou. Roussy lost his head, lord I said, blown through the roof. They wrapped him up in cool sheets and I went wandering. Now I'm in cool sheets, lord I said, holding my thing.*

Soldier Boy jumps up, standing on the bed over Nicole.

> SOLDIER BOY (singing): *Oh lord, I'm taking my time, losing my mind, everything blows! Oh lord, drink till I'm blind, out of the hole.*

He jumps down and pours a shot, shoots it, drops it. He runs to the window and slams the shutters closed, blotting out the moonlight. He jumps back into the bed, covering Nicole with his body, grabbing her by the hands. He raises her hands into the air.

SOLDIER BOY (singing): *Working for your father, makes your hands so rough, but your belly is so soft, lord I said, holding your love. I don't have a diamond and I don't have much gold . . .*

NICOLE (singing): *Mostly, I have skin . . .*

SOLDIER BOY (singing): *Lord I said, show me, Nicole.*

The sheet flies up into the air and then back down over their bodies. The candle blows out.

BLACKNESS.

The sounds of breathing, banging, huffing, BREATHING, BANGING, and heavier breathing and more banging fill the room.

And then . . .

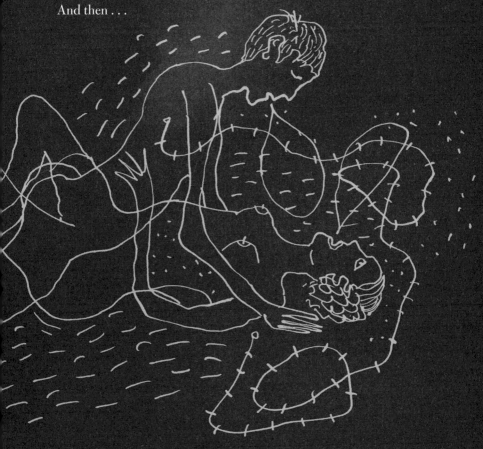

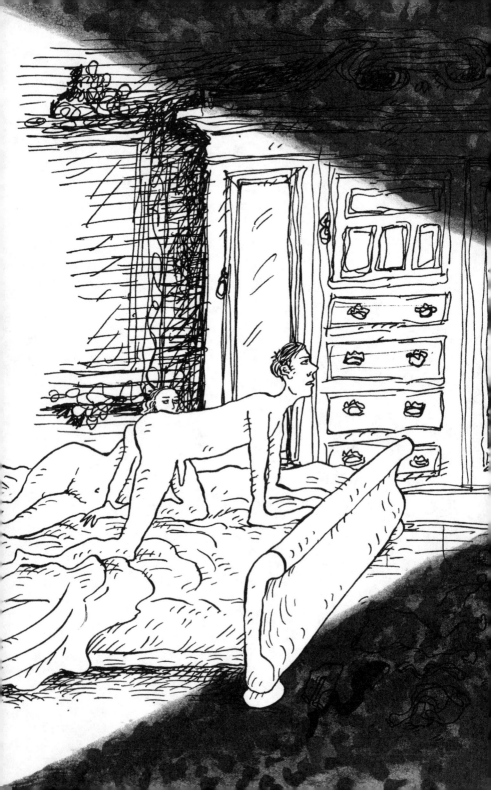

A strange mechanical sound, like a clock's ticking, but as if time were moving at an unimaginable speed. A flicker of light in the darkness reveals Soldier Boy's and Nicole's bodies, moving against each other. The light catches Soldier Boy's attention as he moves up Nicole's chest across her breasts and to her neck. As he holds her head in his hands, he is transfixed by a pinhole light coming through the wall. It is an impossibly thin pinpoint of light that does not spread or bleed. He crawls over her toward the flickering beam. She grabs at his body to bring him back on top of her, but he breaks free and puts his eye up to the hole, as he did in his dream.

On the other side of the wall is the exact same room he is presently in. It has the same bed, window, door, and on the bed is a man who looks exactly like him, with a woman who looks exactly like Nicole. It is the exact same moment that, minutes ago, Soldier Boy experienced, but different. It is not dark. In fact, it is as if there is no roof over the otherwise identical room, but more disturbing,

there are other people in the room as well and they are WATCHING the soldier and the Innkeeper's daughter in the act.

Soldier Boy pulls back from the hole and turns to Nicole with face pale and body tensed.

NICOLE: What? What is wrong?

Soldier Boy backs away from Nicole, who suddenly seems embarrassed by her nakedness. She pulls her gown up over her body and steps backward away from him toward the door.

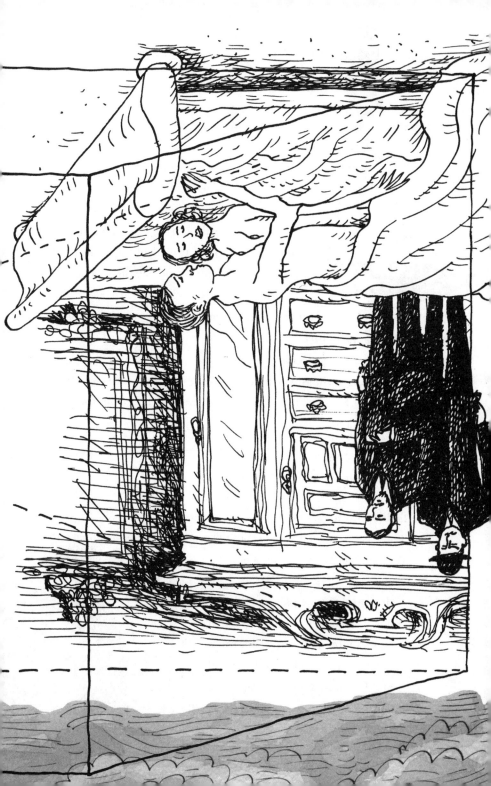

NICOLE: I'll leave you alone.

SOLDIER BOY: I, I'm sorry, I . . .

Before Soldier Boy can say anything, she is gone.

He turns back to the hole and slowly approaches it once again. The light is no longer flickering. It has dimmed. Shaking, he looks back in.

There is no one there now. Just the empty day-lit and roofless room. It is identical to his room at the inn, except there is no one there. The only other difference is the machine that sits in the middle of the room. It looks like a picture camera and is pointed directly at the bed.

Soldier Boy pulls his gaze out of the hole again and thinks.

Jumping up, he puts on his clothes, throws his door open, and walks out dazed. He goes down the hall, up to the room next to his own, and opens the door.

INTERIOR/NEIGHBORING ROOM/SAME

Soldier Boy finds himself in an empty bedroom much like his own. There is no one in it and it is not the room he saw on the other side. When he looks down the adjoining wall he sees THE HOLE.

It is in the same place as the one on his side would be. He bends down and looks into it. He can see his room but it is blurry and slightly out of focus. The most disconcerting part is that everything in his room appears to be upside down.

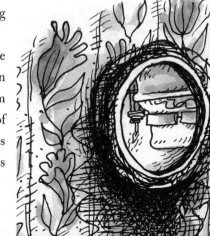

He sits back against the wall, his mind racing to find an explanation. While scanning the room, his eyes stop on a large cabinet. Soldier Boy slides it in front of the hole, and then steps back to survey his work.

INTERIOR/HALLWAY/SAME

Soldier Boy walks down the dark, creaky hallway. As he passes Nicole's room, he leans his head next to her door. He hears her crying on the other side. He keeps walking, down the old rotting staircase and into the sitting room.

INTERIOR/SITTING ROOM/SAME

Sitting in the same place is the balding man with a newspaper over his face. Soldier Boy sits down across from him and stares at the cover of the paper, now with a completely different headline.

Two Men from America Can Fly Like Birds

A picture shows two men with an airplane made of wood and cloth, presenting it proudly in front of the Eiffel Tower. Below it is a smaller headline for another story; this one is the same *Iéna* story as before, but now reads:

117 Dead!

SOLDIER BOY: One hundred and eighteen dead.

The man with the balding head lowers his arms, resting the newspaper on his lap, revealing a portly face and swirly mustache that winds at each end. He looks familiar.

PROFESSOR: Yes?

SOLDIER BOY: Now it says one hundred and seventeen. Is that the same paper?

PROFESSOR: The same paper as what?

SOLDIER BOY: As before!

PROFESSOR: Before what, my friend? Have we met?

SOLDIER BOY: You look familiar.

PROFESSOR: I don't think so. I can't see how our paths might have crossed before.

SOLDIER BOY: In the hole, in my wall . . .

PROFESSOR: Are you all right? You look like you've seen a ghost.

SOLDIER BOY: What does that look like?

PROFESSOR: Pale, friend, you look pale and white. Maybe I've seen one.

SOLDIER BOY: Seen one what?

PROFESSOR: A ghost. A moment ago, I was perfectly alone and now, poof, here you are.

SOLDIER BOY: I am here. I just came down from my room. I arrived earlier this evening from Toulon. You were behind your paper.

PROFESSOR: Ah yes, the soldier boy.

SOLDIER BOY: Are you a doctor?

PROFESSOR: In a matter of speaking, I am.
Although I don't practice and one can't be
a doctor without practicing. At least it
wouldn't be wise to. One must keep up with
the latest practices, as in this day and
age, science and medicine change in the
blink of an eye. Yesterday's cutting edge
is today's barbaric black magic. I am more
of a doctor of thought. I consider myself a
solver of mysteries, a detective of sorts, an
observer. I wake up each morning and think
to myself, "What will I observe today?" And
then I observe, take notes, and see . . .
where the story takes me. It's far less
dangerous and risky. You said you were from
Toulon? That was where that terrible thing
happened. Did you see it?

SOLDIER BOY: I did. I was there.

PROFESSOR: My poor dear friend, that must
have been a horrible thing to see. I hear
there were many deaths.

SOLDIER BOY: There were many.

PROFESSOR: You must be quite shaken from
such an experience.

SOLDIER BOY: I am not sleeping well, and I'm
afraid I'm seeing things that are not there.

PROFESSOR: That could be serious. What kinds
of things?

SOLDIER BOY: There is a hole in a wall of my
room, and through it, I see myself exactly
as I am, but in a different place and time.

Although he looks exactly as I do, he is not
me.

PROFESSOR: Seeing yourself through a hole.
That is strange. [chuckling] I'm afraid my
diagnostic jibber-jabber is not what it used
to be. It could be many things, it could
just pass or . . .

SOLDIER BOY: Or what?!

PROFESSOR: Maybe you have met the architect
of your own reality? I would like to think,
as we all often do, that I am the center
of a universe I have created. I guess it is
possible that I am not the creator of this
particular world I am observing—unlikely,
but not impossible. I often like to imagine
multiple universes that I occupy; I guess
one of them could be not actually of my
own design. Perhaps you are the architect,
but which of you, and if neither, then who?
There are huge ramifications, whichever head
of the same snake survives the battle with
itself.

SOLDIER BOY: I don't know what I should do.
What if it continues? What if it gets worse?

A long silence falls as the Professor studies Soldier Boy intensely.

PROFESSOR: It sounds to me like there has
been an intersection, an event, as I like
to call them. They seem to happen around
me, so I am not surprised. I don't normally
do this, but I'm going to write something
down for you. The next time you experience

these symptoms, read the words that I have
written. They might help. All I ask is that
you report the results back to me.

The Professor scribbles meticulously on a sheet of paper for a
long while as Soldier Boy waits patiently. He then folds it and hands
it to Soldier Boy.

PROFESSOR: No peeking, now! Only use it
when the symptoms show themselves. All I
will tell you is that if you can confirm
any of these steps, then you simply have
shell shock. It's common among soldiers
in wartime, or after any event of extreme
anxiety and terror.

SOLDIER BOY: And if I can't?

There is a long and uncomfortable silence.

PROFESSOR: We are all nothing, but we are
also everything, aren't we? We never know
which we are or when. What you are seeing
could be very significant. If you should find
that you are everything, then, sadly for
me, I might not exist at all. This would be
a terrible thing to discover for any man.
But then again, how could one turn down the
opportunity to find out?

From outside, belligerent singing is heard.

PROFESSOR: Ah, here he comes again. Every
night it's the same thing.

SOLDIER BOY: Who?

PROFESSOR: The Innkeeper drinks one town over every night and then stumbles home, crying at his daughter's bedside while she sleeps. Then he falls flat on his face, out cold, in the doorway of her room. It is best if you are not here when he returns. He's a violent drunk.

EXTERIOR/GOOD INN/NIGHT

The Innkeeper stumbles down the moonlit dirt road toward his inn.

INNKEEPER (SINGING A CAPPELLA):

She left me no address, but I would make a bet, between the ninth and the eighteenth, she's getting ahead. She said she met a guy, he's gonna buy her bread, they saw a show at the Grand Guignol, she's getting ahead.

I have to get me clean, on account of how I feel, I never saw you in black and white, that is how I know you're real.

I have to get me clean, she's getting ahead. Woo-hoo!

She left it all behind, just to get ahead. A young lady from Avignon, getting ahead. A young lady from Avignon, stuck in my head, woo-hoo!

The Innkeeper pushes through the front door and falls flat on his face, unconscious, in front of the Professor, who once again has the newspaper held up in front of his face.

Soldier Boy stands over the Innkeeper and looks back to the Professor, who, enthralled with his paper, pays no attention.

Soldier Boy shrugs and uses all of his might to slowly drag the Innkeeper through the doorway. He drags him up the stairs and down the hall, passing Nicole's bedroom. She is still weeping inside.

Finally, he arrives at the end of the hall at what seems to be the Innkeeper's room.

Soldier Boy falls over, out of breath, just after pushing him through the doorway.

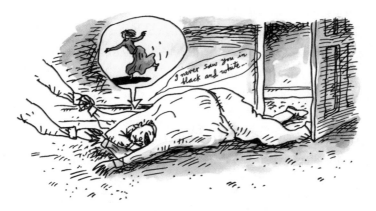

INNKEEPER (waking for a moment, turning to Soldier Boy and grabbing his shirttail): I never saw you in black and white . . .

And he is out like a light.

Soldier Boy stands up and steps carefully over him as he walks back down the hall to his room shutting his door behind him.

Soldier Boy sits on the end of his bed staring at the dim light coming through the hole in the wall. It's as if he is waiting for something to happen, . . . and then it does.

The mechanical sound returns. There is a fast whizzing and whirling. The light projects through the hole even brighter than before and begins to flicker. Soldier Boy pulls the Professor's piece of paper out of his pocket and holds it tightly in his hands. He is just about to stand and peer into the hole once again when there is a knock at the door and then a whisper. It's Nicole.

SOLDIER BOY (facing the door): Just a minute.

Soldier Boy is advancing again toward his initial quest. He kneels down and looks into the flickering hole.

And there HE is. Sitting on the edge of the bed, staring right at himself. This other him stares at the hole from across the other room.

Daylight seems to be flooding in from above and his second self is surrounded by people. He is watching his other self on the bed, now watching him in return.

Soldier Boy begins to shake. He lifts up his trembling hands and opens the piece of paper in the flickering light. This is what the first line reads:

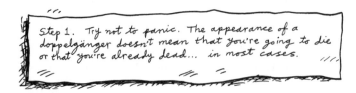

Step 1. Try not to panic. The appearance of a doppelgänger doesn't mean that you're going to die or that you're already dead... in most cases.

Soldier Boy looks back into the hole, and before he can open his mouth to say what his mind was about to make him say, his second self speaks it first.

OTHER SOLDIER BOY: Well, that's a relief.

Looking back into the hole, Soldier Boy sees the back of a man dressed in a suit. He is balding with a distinct swirling mustache curled at each end. He stands next to a camera that is pointed directly at his second self, who is now speaking on his behalf at the edge of the bed.

Soldier Boy looks down at the paper to see what it says next:

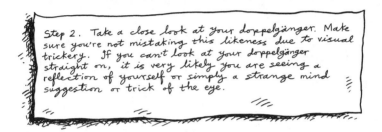

Step 2. Take a close look at your doppelgänger. Make sure you're not mistaking this likeness due to visual trickery. If you can't look at your doppelgänger straight on, it is very likely you are seeing a reflection of yourself or simply a strange mind suggestion or trick of the eye.

Soldier Boy turns his head and looks out of the corner of his eye into the hole. Nothing changes.

He reads the next two lines:

Step 3. Consider the many disorders that could lead to such a phenomenon. One such condition, Doppelgänger Syndrome, causes you to believe that a doppelgänger exists. Those suffering from this strange disorder have been found to believe that they have a second self who is living a completely alternative version of their life or that this "other" has stolen their spirit, or soul.

Step 4. Understand that your memories, like your perception of place, time, and self, are relative. It is common to confuse two events in one's mind. Déjà vu, for instance, is a common occurrence. Maybe you had been hypnotized and were not aware of this? Insomnia as well can create mental breaks that can lead to confusion and waking dreams. Science is often an important ally in deciphering the strange things that afflict mortal men.

Before he can read the next line, there is another, more insistent knock on his door.

He looks away and stands up, shoves the paper back into his pocket and opens the door. It is Nicole. She forces her way in and throws Soldier Boy down on the hard wooden floor. She climbs on top of him. She takes off all of her clothes and proceeds to do the same to him. He forgets himself and pulls her up against him. They become one.

The light projecting through the hole covers them in a flickering display. Soldier Boy lifts Nicole up by the waist and they crash into the wall against the hole.

SOLDIER BOY: There are two of us.

NICOLE (in between heavy breaths): Yes, I know.

SOLDIER BOY: No, two of each of us!

NICOLE: What are you saying?

SOLDIER BOY (singing a capella): *I'm losing my mind, I don't want to die, anything goes . . . down in this hole!*

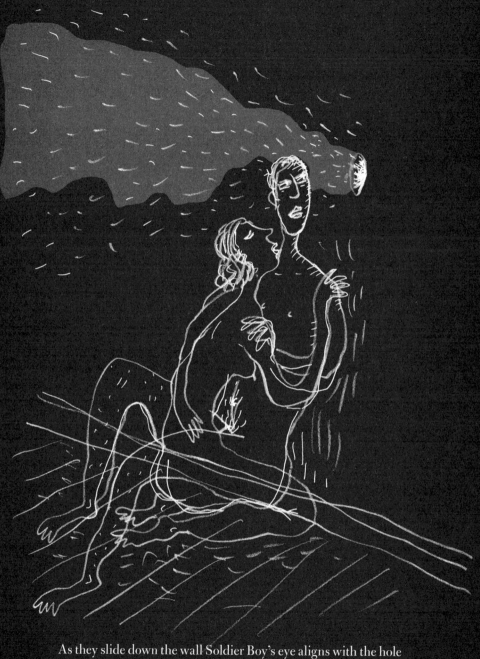

As they slide down the wall Soldier Boy's eye aligns with the hole
and he finds himself looking at a mirror image of himself and Nicole.
They are entwined against the wall on the opposite side of the hole.

SOLDIER BOY SCREAMS and smashes his fist through the breach, blotting out the light. As he removes his arm from the unwanted peephole it drips with liquid. His eyes roll backward in his skull.

CUT TO BLACK:

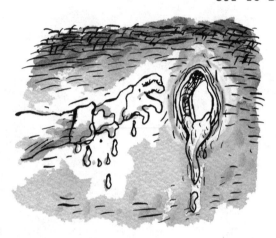

INTERIOR/SOLDIER BOY'S ROOM/NIGHT

Nicole lights a candle. Soldier Boy lies on the bed and Nicole wraps his bloody hand in a bandage. He stares dazed at the now-dim light in the hole.

NICOLE: When I was a little girl, I wanted to leave this place. I wanted to go somewhere bigger.

SOLDIER BOY: Yes? And why didn't you?

NICOLE: My mother told me I had to wait my turn. I didn't know what she meant. Years later, my father took me to Paris. It was only for a day. I mainly waited in carriages. I saw the city from the frame of the carriage window. It was like a picture,

but it was moving. Can you
imagine? I saw these moving
pictures of Paris, but really
I was just in a coach seat,
watching the world through a
window. I didn't understand,
but we had only gone to the
city to find my mother. She
left my father for Paris.

Nicole stands up and walks to the door, then turns back.

NICOLE: But I never did.

SOLDIER BOY: I'm sorry.

NICOLE: Don't be sorry. I
could have had my turn.

SOLDIER BOY: Maybe you still
will.

NICOLE: Can you see the
future, Soldier Boy?

SOLDIER BOY: I don't know. Sometimes I think
I see what occurred in my past, but it only
comes in flashes. I was born in Paris, I know
that much. I had an aunt who raised me until
I was old enough to join military service.
Once I told her I remembered my birth and
that it was very bright. She said that it
would not surprise her. I was born at the
great fair, on a night that lit the sky
over Paris so bright, it seemed like it was
day. I'd like to see that again, but I think
that a night that bright could never happen
again.

She smiles, and then looks sad. Nicole closes the door behind her. Soldier Boy is alone.

He pulls the paper back out of his pocket and opens it, beginning to read the last two lines:

Step 5. It's time to try to talk to your doppelgänger. Maybe he is actually a long-lost brother you never knew you had. Perhaps there is some logical reason that another you walks the earth that you have yet considered.

Returning to the hole, Soldier Boy puts his mouth up to it.

hello?

SOLDIER BOY: Hello? Can you hear me? Hello?

He peers inside but there is still no response. He continues to read . . .

... If you followed steps 1 - 5 to no avail, there is always step 6...

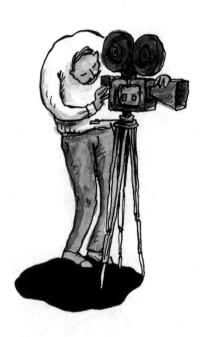

CHAPTER 4

The Blue Movie

aylight shines through the window. The Soldier Boy wakes
up naked and bathed in a harsh light that makes his entire
body glow. Next to him lies the Innkeeper's daughter, her
body spread out across him, wearing nothing but the bedsheet,
which barely covers her. She too is incandescent from the
bright light that covers them.

A voice yells out, **"Cut!"**

An arm reaches out to the man in the bed, holding
clothes. George dresses casually. The clothes are not
those of a soldier. As he dresses, NICKIE LOUISE
WILLY sits up and shouts.

NICKIE: Are we done or are
we taking a break? That was
really easy. I could do it
again. Albert? Are you out
there? Was it good? It felt
good!

The room is exactly the same as what Soldier Boy saw through the hole, but the ceiling is open to the sky. There is no roof. In front of the bed is a thin tripod. On top of it there is a moving picture camera. Standing around the camera are three men. Behind them, the warehouse is empty and seems to expand forever in all directions.

The three men ignore Nickie Willy as they fiddle with the device. Farther behind them is the man Soldier Boy saw through the hole. He sits in a wooden chair watching the men work. Nickie Willy, from the bed, continues to speak.

Black Francis and Josh Frank

92

NICKIE: Albert, did you hear me? I said it was quite easy!

Albert Kirchner, the director, pulls out a pipe and lights it. His bald head and mustache are in full view. This is the same man from the sitting room at the inn.

One of the men walks over and stands next to him, watching the actors dress.

CINEMATOGRAPHER: I thought it would be strange. It's no different than taking pictures of animals on a farm or a train pulling into a station. It's really quite easy, isn't it?

LÉAR (yelling out): Call me Léar, woman, LÉAR!

NICKIE (to George): What did he say?

GEORGE: He wants you to call him Léar. He likes to be called Léar.

NICKIE: Why?

GEORGE: He's said so a hundred times. Does it matter?

NICKIE: But it's not really his name.

Léar stands up next to the Cinematographer and they walk back into the emptiness away from the set.

CINEMATOGRAPHER: What are you going to do with this one? One for the arcades? I doubt this could be played anywhere in public, you know. Gaumont just reopened his Palace theater. I don't expect that they would play this there. So what is the plan? Have you thought about that?

LÉAR: I have thought about it.

CINEMATOGRAPHER: I didn't think it would really work. I didn't think you'd find anyone to do it, but you did. How did you do that?

LÉAR: Haven't you heard? Everyone wants to be in pictures!

CINEMATOGRAPHER: The Lumière brothers will never show this either. Ever.

LÉAR: We can't sell these pictures to other people to show. We have to show them ourselves. When Edison put the first sound on a cylinder, he didn't count on anyone else to figure out how to play it back. No! First, one must figure out how to capture it, then how to release it. One step at a time.

What we do, my friend, is make pictures. Not just pictures, but pictures of the naked truth. These pictures we collect when sewn together will tell stories the likes of no one has ever seen or experienced before. I'm creating something new here. More than a mere *succès de scandale*. We are going to bring sexuality to cinema!

CINEMATOGRAPHER: Where did you find them?

LÉAR: Find who?

CINEMATOGRAPHER: Your actors.

LÉAR: Oh, those two? Here and there. A little more there than here. Our investors look bored. You should go and entertain them.

The Cinematographer darts back to the camera that the two men are still admiring.

CINEMATOGRAPHER: Gentlemen, what did you think? We believe that, with your help, we can shoot two of these a week with a triple return of your investment. We just need the equipment for three days a week.

GENTLEMAN 1: Why not just go through Pathé?

GENTLEMAN 2: I'm told he's built six.

CINEMATOGRAPHER: Well, first of all, the Lumières refused our previous offers of ten thousand francs for a camera alone; Pathé wanted fifteen! And with film stock going for up to fifty francs a meter . . .

LÉAR (suddenly stepping between the two men): Pathé! Pathé wants to own anything that's shot with his cameras. Edison wants to own it whether it's shot with his cameras or not. The Lumière brothers won't show anything they don't shoot themselves. Nobody wants to share and nobody but LÉAR would be bold enough to put their name behind this. Why would we want to share what is sure to make more money than they could ever imagine making? We are not making their tedious drawing room dramas and light farces. This is the future. This is art.

GENTLEMAN 2: Art. Are you sure? Is that really the idea? I would think this would appeal more to the lower class.

LÉAR: Why shouldn't the lower class have art? Maybe that's just what this country needs. An art that will humble the upper class and bring them to their knees. Let's get everyone on the same level for a change. The lower class is just the upper class without a sitting room. I'm going to get everyone into the same room, I promise you.

GENTLEMAN 1: It doesn't look very hard. Couldn't anyone do this?

Léar turns to them and grabs their collars, pulling them toward each other. All three of their faces are inches from each other. Spittle flies as Léar speaks.

LÉAR: It's easy to shoot pictures of people naked. Anyone can shake their ass in front of a camera. You fellows with your little

pricks could even do it. What is difficult, gentlemen, is telling a good story at the same time.

Léar releases them and walks away. The men straighten their coats in shock. The Cinematographer smiles a nervous smile.

CINEMATOGRAPHER: That's Léar. Don't take offense. He's an artist.

The Cinematographer escorts the men to a door at the edge of the warehouse and watches them shuffle out at a loss for words.

INTERIOR/WAREHOUSE SET/SAME

Léar sits on the edge of the bed staring at the camera in front of him. The investors and actors are gone now and the Cinematographer is carefully packing up the delicate machinery.

LÉAR: So they agreed?

CINEMATOGRAPHER: Yes, they did, no thanks to you. If we are going to be asking people for things, you might want to work on your joie de vivre.

LÉAR: When you get back into town, I want you to write to Bernard Natan in Romania. I will arrange passage for him. He will be able to help us.

CINEMATOGRAPHER: Very well. So the film is finished then?

LÉAR: No. The film is not yet finished. What do we have? We have a soldier who comes upon an inn, has his way with an innkeeper's

daughter, and then something happens.
Something that changes everything, but what?
I shall have to think about the *grande
finition*!

INTERIOR/SOLDIER BOY'S ROOM/SAME
(in black and white)

Soldier Boy backs away from the hole and collapses next to it. He is sweating and shaking. There is a hard knock at his door.

SOLDIER BOY: Go away!

INNKEEPER (offscreen): I will not. You haven't come out of that room in two days! If you're going to stay any longer, you'll have to pay! Now! Come on!

Soldier Boy looks back to the hole, which is now double the size it was before.

SOLDIER BOY: Leave me alone. I'm not well.

Soldier Boy can hear whispering on the other side of the door. It sounds like Nicole is whimpering and pleading with her father, who continues to bang on the door. The door begins to shake and rattle as the Innkeeper slams into it with all his weight.

Soldier Boy looks down at the last lines on the paper the Professor gave him.

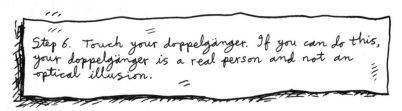

Step 6. Touch your doppelgänger. If you can do this, your doppelgänger is a real person and not an optical illusion.

Without having even finished reading the lines, Soldier Boy has decided. He runs back to the table by the side of his bed and grabs his shirt and his pouch of coins. He punches the hole, making it larger. He steps back to look at the large hole in the wall. A cold, airy, damp darkness within seems to expand without end. The Innkeeper is moments away from busting the door off of its frame. Soldier Boy looks down at the paper one last time, drops it, and then jumps into the hole.

He squeezes his midsection through the giant slit; it is just big enough for him to fit through.

The Innkeeper stomps in to find the room now empty and a large hole in the wall. He looks into the nothingness.

INNKEEPER: What can this be? This is impossible. There is a giant hole in my wall! What did he do? Where did he go?

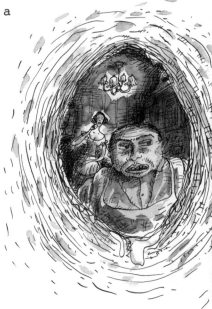

Nicole stands in the doorway, her face swollen from crying.

NICOLE: If I had to guess, Paris.

The Innkeeper notices the paper on the floor and picks it up. The last thing the paper says is:

If you do succeed
in touching your
doppelgänger, and
this IS actually
you, then you
must ask yourself,
who is the person
that has just
touched you?

Inter-Mission:
Meanwhile . . .

If one traveled south with the bustling city at one's back, out of the safety and security of the lights of Paris, across a rickety bridge, and down the last paved street, which leads to roads of dirt and soot that slowly run off into the tiny veins of the Seine, most would think they had made a terribly wrong turn somewhere along their way.

Unlike most, however, Léar was very familiar with this part of town, a string of warehouses owned by questionable characters who wouldn't ask questions, with the understanding that the favor would be returned.

One particular building was in between uses, having been recently acquired in a questionable game of chance by said questionable characters. Soon, this giant building would be home to one of the many unregulated absinthe distilleries that now dotted the waterway below the city. This was a new venture for men who were always ready to exploit the latest condemned social activity.

In this case, a green liquor had come under attack. The public

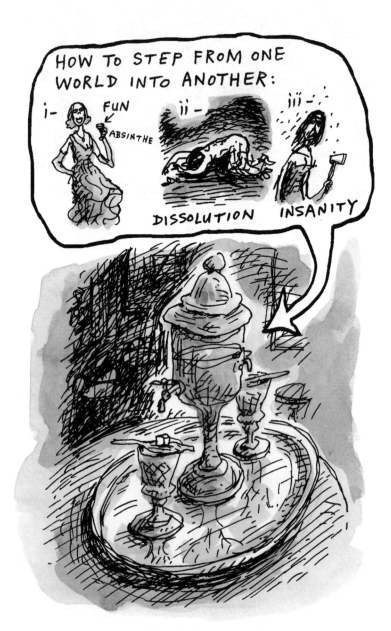

had been led to believe that the reason was safety. This very popular drink was apparently driving people crazy. At least one case of insanity had been proven when an innkeeper had come home from drinking and murdered his wife. The fact that there was no way to prove he had been drinking absinthe wouldn't stop the wine merchants from taking their fight against this menace to the highest court. That the wine merchants had everything to gain from absinthe's being condemned wouldn't ever be questioned. In recent years, absinthe had crossed the boundaries of class and had become the preferred beverage of every man, cutting a hole in the deep pockets of the winemakers of France.

In the end, the real beneficiaries of the coming absinthe ban would be the same people who had ended up causing the green fairy's fall. Léar knew these men, who had been making bootleg bottles with questionable substitutes for the more expensive ingredients. But he also knew men like the Lumières and Mr. Pathé. After years of infighting, backstabbing, and failed business affairs with his cinematic peers, he had finally come to the conclusion that if he wanted to be a successful artist, he was better off aligning with the criminal "entrepreneurs" of the Paris underworld than with his old colleagues, whom he would often refer to in conversation as "uninspired, bloated old businessmen."

But Léar's new alliance was sensible. They were going into business and both of them needed holes in the roof.

A space in the ceiling had already been carved out for one of the many vents that would be needed for the liquor fumes. Léar couldn't believe his luck. He had to find an out-of-the-way place to shoot his picture. The location needed to be open to the elements so the sun could reflect off his subjects' skin enough to burn a bright image into his film. A warehouse with a giant hole in it, in a part of town that no one wanted to go to, in a building that didn't officially exist, was a triumph.

Moments Later . . .

A door opened on the side of the warehouse, and out of the darkness walked Nickie—she was the woman who played the Innkeeper's daughter—followed by George, the actor who played Soldier Boy. They stood in the frozen morning air next to each other in awkward silence.

"Well," George said.

"Well, well . . . ," Nickie replied.

"Adieu, then," George said, applying a top hat and walking off in the direction of the city looming in the distance.

Nickie yelled after him, "It was a pleasure! We should do it again sometime!" She laughed wildly, then did a little dance in place, then laughed again, and then she bowed.

Nickie was far more comfortable performing for the camera than George was. She was used to presenting her body for men at a very popular show at one of the many theaters that line the streets of Montmartre. All the girls were doing it. It was not so much a reach to dance on the stage in thin garments and then do so on film. Many of the girls had already posed for their friends who painted their bare flesh on walls, canvases, and posters.

Nickie herself could be seen all over town plastered on pillars and side-street walls in Monsieur Chéret's latest poster, an advertisement for the show palace where she would dance. However recognizable her image presently was, it was her name that she wanted the world to know. Having spent the better part of a decade as the backstage inspiration for her many talented friends, she was ready to become more than a muse; she was ready to be the main attraction.

It was one of these images, posted on a side street below Léar's flat, that gave him the idea, and he had to have her! Originally, when he approached Nickie, she turned him down. She had worked with Léar once before and it had *not* conjured all the wonders he had promised. Léar did not like being turned down. It wasn't something he accepted on any occasion.

He was especially infuriated at her narrow-minded view of the arts, which she had made all too clear in a most unattractive

THE GOOD INN

105

intoxicated state the night before. After he'd approached her with his interest, she had stated in a most public display for all to hear that "sex on a painting canvas is clearly art, but sex on a moving canvas could never be."

Overnight, however, her opinion on the matter had changed, most likely when she woke to find that all her money had been spent. She arrived for work the following day, either in good spirits or more likely because of them. George could smell it all over her body.

George was another story. How did he end up on the other end of Léar's lens? In a bed with the most flexible woman this side of the Moulin Rouge? These were exactly the questions that George was asking himself while walking back across the Pont Neuf to his comfortable flat on the side of town that someone like Nickie Willy would feel uncomfortable in.

The term used for the likes of George and his ilk in Nickie's circle was *bourgeois*. But this term, much like a curse word, had different meanings depending on the place and time. In this time and place *bourgeois* was something to strive for. It wasn't as much about having money as it was showing that you had money. And showing that you had money was quite expensive. George had fallen into this social trap. And it was a trap. No one with a modest salary could ever keep up the appearances that were necessary for long. The latest thing for the new bourgeois was to have a sitting room, and while George had just enough money to finish his fancy new parlor, afterward, there would be nothing left.

His father had spent every penny he had sending George to the finest schools, clothing him in the best threads, not so much for his son's sake but in order to show that he was in the same class as his peers.

So it was to his father's great disappointment that George decided to become an actor. He had squandered his family's savings on a bluff. All in hopes that one day the gamble would pay out and

a son would sneak his way into the upper tier of nineteenth-century Parisian society, or a daughter would marry well. For George, the payoff was nowhere in sight and he was eventually cut off. But that was only part of the reason George was here.

The other reason was because Léar had asked him personally. His exact words were:

> Georgie, my boy, you will make some easy money and it might even be fun. It's no big deal really, every actor sleeps with his costar. You just get to skip the song and dance. You get to skip the foreplay and start by taking her home after a long day's work. It's like we aren't even in the room. You will not be George. You will be a soldier who wanders upon an inn. If you can act out the classics, as I have seen you do, you can act the part of a soldier alone in a room with a beautiful woman whom you will take to bed without even having to introduce yourself! *Voilà!*

Walking away from it all in the cold morning, George had started to doubt if it was such a good idea. There was something about Nickie that worried him, and he wondered if he had really thought the whole thing through. It had been much more uncomfortable than he had expected it to be. Most important, it didn't feel like art. It just felt like bad sex. Léar had promised him that in the end it would be a more popular attraction than anything seen on a Parisian stage. Even more bold was his statement "Soon every respectable actor in town will be doing it."

George opened the door to his flat and stood in the doorway looking in on the nearly finished sitting room that his previous night's work would hopefully finish paying for. A letter waited for him on his entry room table. He opened it. It was a request for his presence at an audition. The letter was impressively official. From

George's face it was clear he was familiar with the people who'd sent it.

George's stern, frozen face warmed; he had been waiting for something like this.

"Shakespeare, Georgie, Shakespeare."

Whether by fate, or chance, or a deal with a devil named Léar, George *was* going to get his break, and his sitting room.

As George closed the door behind him, on the cold and on the previous night, another door in a neighborhood a short coach ride away swung open.

Nickie's night was just beginning. She had a new dance in mind to perform on this coming night, and no dance could be performed without its going by the owner of the club.

THIS IS A MAP TO YOUR FUTURE LIFE

A → B

Five Minutes Later

Nickie burst through the backstage door, turned, spat toward it, straightened herself out, and marched out of the alleyway into the crowded streets.

If that lowlife didn't want her new act, then there were plenty of other lowlifes who would! She would take her act elsewhere. What had he called it? "Lewd"? She called it "The Willy Can-Can, Mainly Because She Can-Can."

"Too much skin," he said. He'd be shut down, or worse.

Turning a corner, Nickie found herself standing directly in front of the Moulin Rouge. It towered over her, as it always had when she had taken her stance at its doors before. This time she was going in, and she wasn't going to leave without a spot on the marquee.

Five Hours Later

"Well, well, Nickie Willy, the new queen of the cancan on the main stage, on the main street, in the biggest show in town. I'll have to draw up something special for you and make sure it's on every wall on every building down every street." Sitting beside Nickie at their usual café was Jules Chéret.

The seat beside Nickie had always been the most desired, even before all of Paris knew of it. To the often-starving artists of Montmartre, to be in the presence of Nickie Willy was to be moments from profound artistic inspiration, and one never knew when inspiration might strike. Nickie had a sparkling light that was always turned on, bathing all around her in a warm electric glow, and even the darkest, most troubled artist's soul couldn't help but be comforted and invigorated by it. The previous occupant of the chair beside Nickie's had been Toulouse-Lautrec. Nickie and Toulouse-Lautrec had always looked quite strange together. She towered over him even while seated, creating the effect of a distorted mother and man-child. They were the oddest pair. Now the seat was held by Jules. Jules Chéret had been around for many years and had seen it all. He had seen Paris change—in his mind, for the worse. For the young, bright-eyed Nickie, this was still just the beginning. For men like Jules and Félix Fénéon, the end always seemed nearer.

Toulouse-Lautrec had been a close friend and confidant of Nickie's for her first year in Montmartre. At the time, he was the most celebrated *affichiste* in town. Pierre Bonnard, who was also at the table, was a contemporary of Toulouse-Lautrec and Chéret. He had worked his way up from being an illustrator for the *Paris Daily News* to being acknowledged as a bona fide artist. His work was beginning to gain as much notoriety as that of Seurat and Manet, who also were fans of his work.

The poster artists of Paris were Nickie's people. They had done what no artists before them had been able to: made money.

Toulouse-Lautrec himself had not needed money, as he came

from it, but when his friends saw that businesses were willing to pay handsomely for (at the time) their otherwise worthless art if they simply incorporated the names of products in the design, they happily offered their services.

A whole new generation of young starving artists were, for the first time in their lives, not starving. More important, their work was being seen and the streets of Paris were their art gallery. Of course, this bold shift in the marrying of art and commerce came with a price. Many shunned them as sellouts, phonies, or slaves to the bourgeois. Many alliances and friendships had been broken.

Toulouse-Lautrec was now deceased. In the one year that he had spent with Nickie before his untimely death at only thirty-six, he had left his mark on her. From that point on she was to be owned by the lights of Paris alone and never by a single man, no matter what gifts he came bearing. It was Toulouse-Lautrec who had introduced Nickie to Félix Fénéon. Pierre Bonnard and Toulouse-Lautrec had illustrated for the magazine *La Revue Blanche,* which Fénéon edited. Félix, who had once celebrated the early works of his peers, now threatened their lives for selling out and turning their art into advertising. Their relationships soon soured, as did his affair with Nickie—on an occasion when she overheard his response to a poster bearing her image, he had said:

> This one is just like the rest of his works, the female types
> are plump and they grind their asses and stick out their
> tits, grinning from ear to ear. One would think that Nickie
> Willy would have had more to offer the world when finally
> we were able to peer upon her hidden talents; alas, all she
> was hiding was skin.

After she heard of his comments Nickie's already delicate friendship with the always controversial Fénéon soured. Her friends

of course sided with her, and would lovingly describe her as half fairy and half streetwalker, and this she took as a compliment.

Félix was becoming the stuff of modern French folklore and was spoken of lovingly by his friends as some sort of cultural terrorist. He had even begun a well-organized underground campaign to tear down every poster in Paris, and he would have continued to, if he didn't have other problems. At the moment, Fénéon was wanted in connection with an explosion in a nearby café, of which he may or may not have been the architect. It was in protest of the political state and how it had suffocated his preferred artistic movement—one of the many things that disappointed Fénéon about mankind and what it had done to *his* Paris.

Nickie loved all of these men in her way and never took sides. She stayed neutral and found that by doing so, she was always the person

they could turn to for a favor. Favors were her currency. Tonight she was surrounded by all her most brilliant friends. Beside her, Chéret and Bonnard argued passionately about Fénéon's artistic and political turn. Fénéon was noticeably absent after his recent remarks about their dear Nickie. On the other side of the grand table sat celebrated musician Erik-Alfred-Leslie Satie with Claude Debussy, who was quietly comforting his friend about a drubbing he'd recently received from a critic who'd referred to him as a "clumsy but subtle technician." Debussy was suggesting that Satie define the terms of his own brilliance. "You should call yourself a 'phonometrician'!"

But politics and art bored Nickie. For her, it was all about the skin, the bones, where you put your hands, and how little you needed to wear your clothes.

Nickie failed to mention, however, that her hypnotizing gyrations were, in the end, only half of what had gotten her this coveted spot in the biggest show in town. Colette, who had up until that night been the star of the show, had kissed another woman onstage. Not just any woman, her mentor, Mathilde de Morny, the Marquise de Belbeuf—whom she had become romantically involved with. The two had performed a new pantomime entitled *Rêve d'Égypte*. A small riot broke out, which the police had been called in to suppress. Her scandalous act and its fallout had set in motion Nickie's rise to fame.

And on this night, George would get the role he desired at an important theater in town. It would be his first big break on the road to many.

Nickie would dance at the Moulin Rouge in place of Colette and be an overnight success. From that night on, every man of importance who came to see her show would request her company for a late dinner. Gifts would always be given. Her risqué dance routine would become the talk of the town. Her act would even inspire a filmmaker named Méliès to film her performance so it could be seen all over the world.

Five Months Later

Now . . .

Léar paid attention to nothing outside of his own conquests except the competition. As he worked to finish his film, others had heard of his plans. From Méliès to Pathé, they all were preparing their own risqué reels. At the time, Léar was not overly concerned. He wasn't just making a pornographic peep show. He was making a film.

The solution of how he could distribute his groundbreaking film had yet to come to light, and this was proving to be a major setback in his plot. He knew Georges Méliès and the others had heard of his grandiose plans and were aware that he was up to something. He also knew they would do what they could to beat him to the punch as they had in the past, and eventually would again. He felt that time was running out.

Before pictures could move, Eugène Pirou had perfected the "art" of the pornographic still. The jump to the moving image, however, was timid to say the least. *The Kiss* was the first attempt. It was exactly what it sounded like, a fifteen-second kiss between two well-dressed, proper individuals of opposite sexes. It had created quite the stir. Men had flocked to the peep show machines to peer down into a little hole in the top and watch this risqué entertainment. The floodgates had been opened and a few enterprising men saw a sea of potential. It was

initially Pirou, the infamous photographer of harlots, the "peddler of skin," who had suggested the idea that to tease one's audience only required a window looking into a forbidden moment from afar, but to seduce one's audience, and then to "have them," one must be in the room *with* these strangers, one must be able to watch them up close and personal, in motion. So far he had only been able to capture the former. The moving picture camera was the first device that would be able to capture an act that was *all* about action.

Léar had met Eugène Pirou while he was competing with the Lumière brothers in the Pigalle with his own projection equipment. Pirou was known for nude photography. His picture cards pushed the envelope and were highly sought after. They were only found in the most obscure and often dangerous places. It was a conversation between the two that led Léar, who at the time went by his less theatrical birth name, Albert Kirchner, to suggest he secure a moving picture camera for Pirou to experiment with. A partnership was born.

Léar and Pirou came together to advance this new genre that would make its actors more "transparent" with *Le coucher de la mariée,* produced by Pirou and directed by Léar. The short starred a young Nickie Willy, who performed a striptease during a bath scene. Léar scoffed at his peers' "modest" attempts to package the exploitation of the sexes and had plans to take it much further. Another early attempt at exploring this genre was *What the Butler Saw,* a mutoscope reel from the early 1900s. It depicted a scene of a woman partially undressing in her bedroom, as her butler shamelessly watches her through a keyhole.

Léar felt these were mere foreplay. They were prudish attempts to capitalize on what Léar, in his heart, knew the men of Paris *really* wanted. These were just child's play, and ten years later, film was moving in a much different direction.

Now it was about the story. The story was what would make this medium real. This was what would elevate it from a novelty to an art.

Léar was planning on being the name behind this art. This is why he had asked for Bernard Natan specifically.

Not long after completing filming, Léar had sat down with Bernard Natan, whom he had paid well to visit him in Paris from his home in Romania. Léar had heard that Natan knew how to distribute the kind of movie he had made. He had supposedly done it before and was in fact the only man who had tried besides Léar and Pirou.

Both Natan and Léar had heard of each other, but they had never met. Léar knew that Natan was a successful director of movies in his homeland and that he had designs on making a splash in Paris. The rumor was that he had also directed, starred in, and successfully distributed a long-form pornographic film throughout his country sometime around 1906.

Men had returned from trips bragging about having been invited to a showing of this film and had described it as like nothing they had ever seen. He also knew that Natan had been arrested for his previous "morally objectionable" cinematic experiments and had served time. It was rumored that he was at present on the run from the law for a number of crimes Léar assumed must have been related to the distribution of censored materials. In other words, he was something of a hero to Léar.

Natan knew that Léar was a successful businessman who had already made "legitimate" movies and was well connected in the industry—an industry that at this point consisted of only three types of people: those with camera equipment, those with projection machines, and those with neither. Léar had access to both.

Natan wanted to meet somewhere out of the way. Léar had assured him that no one in Paris would be looking for him or accusing him of anything, but after spending two years in a Romanian prison, as well as following from afar the trials and tribulations of the unfortunate Jewish soldier accused of treason, Alfred Dreyfus (whose innocence

had been officially and definitively recognized the previous year), Natan had grown even more eccentric and jumpy.

In the end, they met in the last place Léar thought anyone would ever think to look for someone having such a conversation: a church.

Léar picked the place and Natan picked the time. Early on a Sunday morning, the two sat in a pew in the empty church. Léar was not accustomed to waking this early. They had both arrived at exactly seven forty-five A.M. Léar had begged for a later hour but Natan had insisted upon it. He explained that it had something to do with an escape plan. He said that he would have only forty-five minutes, so Léar might want to get to the point.

One wouldn't think a man like Léar would have been comfortable at all in a sanctuary like this, but he explained the moment Natan sat down next to him:

"My first film was *Passion du Christ*. Do you know who my producer was? The Roman Catholic Church. It's true. That is where I got my first break. It was the first film ever to depict the life of Christ. Now everyone does it. But at the time, it was quite shocking that someone would go to that place."

Léar continued. "In 1901, I began making *scènes grivoises d'un caractère piquant* (saucy scenes of a spicy character). My partner's name was Pirou, perhaps you have heard of him? Together we began experimenting with making short-form peep shows more complex and realistic.

"But now," he explained to Natan, "I want to do something that will change everything. I want to reinvent myself and my work. I want to make a movie with sex . . . that tells a story. Christ, if the Roman Church could see me now."

There was a long silence as Natan considered this. For a moment it almost seemed like the two men who had come to a church to discuss pornography were actually praying.

"I fear my exploits abroad might have been greatly exaggerated in

your country," Natan explained. "The French have had a tendency of late to tell fabulous tales about my people, tales that allow for swift superficial justice. I would hate to come all this way to disappoint you."

Léar frowned; he didn't like men who excused their myths, no matter how far from their truth. Whether Natan was or wasn't all that Léar believed him to be, Léar knew that Natan was *his* kind of people.

Léar argued, "We, all of us, have one or two tiny crimes committed in moments of passion fueled by youthful ambition that at the time we had no idea would conjure such ghosts that would haunt us the rest of our lives, implanting a fear that we will be found out and undone. All for naught. But it is *only* this willingness to cross these invisible lines that made it all possible. These gorgeous ghosts are what make us, but we must not allow ourselves to be undone by them. The true artist *never* excuses his ghosts."

Natan ignored Léar's musings and responded with a question regarding the thing that most bothered him about Léar's idea. "Why would you think that these men would want to sit through your 'story' when they can go somewhere else and get straight to the point?"

Léar faced Natan for the first time. Even though Natan was unsure of his new benefactor's idea, he couldn't help but be impressed by his passion. Léar was clearly determined.

Just as the morning sun blasted an ethereal beam through the stained-glass windows that lined the walls, hitting Léar like a spotlight from God Himself, Léar exclaimed, with the enthusiasm and power of a preacher midsermon, "From the moment man picked up the little machine that could turn life into light and make moments immortal, we have been, all of us, experimenting with what we could capture with this magic box. And then one day, they made the magic box capture motion! Men and women, walking. A train, moving.

Smoke, blowing. A gun, firing. These first displays of manipulating light were simply an entertainment, an exhibition. Over time, though, we begin to wonder what else might we be able to do with this canvas where light is our pigment. It was only a matter of time before someone would wonder, 'Can I capture a kiss, can I capture love, can I capture beauty, ahhh, wait a moment, can I capture sex?' The truth is people would much prefer to watch beauty than decay. A kiss garners more excitement than a train shooting toward you at great speed, primed to run you down. Hidden and forbidden worlds filled with beauty, passion, and sex, to put it simply, sell.

"And so myself and my contemporaries who were some of the first men to get their hands on this obscure camera asked our subjects to remove their clothes. And for a moment, that was more than enough to blow people's minds as an extension of that exhibitionism. Even the most impressive magic trick performed with light couldn't hold a candle to the draw of bare skin. But as time goes on movies will now focus on more and more intricate stories. The first reels were seconds long, then minutes. Soon we will have films that are an hour or longer! How long, I ask you, can one have sex for?"

Natan saw where Léar was going with this, and he couldn't help but be impressed. Léar was right. He was crazy, possibly demented, and definitely morally corrupt, but he was also right. Léar wrapped up his call to arms with a manifesto he had been practicing for weeks . . .

My friend, up until 1905 film was considered merely
the work of a machine incapable of intelligence or
interpretation. If it happened to catch the light reflecting
off something naughty, its operator was not to blame. So
what changed? When did the man behind the camera
become responsible for what light his contraption
captured? I would say that it was when we realized that

that light was being controlled by the man and only collected by the machine. Much like a conductor leads his symphony, we are the leaders, if you will, of this visual orchestra, and voilà, that is when exhibition transformed into art. This, my friend, is what makes us artists, and yet, to have this art reach the common man, the only way to compete with what is to come is to make these "blue" movies longer. The only way to make them longer will be to tell a good story.

Léar pounded his fist down onto the rickety bench in front of him, the sound echoing throughout the hall like the last dramatic note in a musical composition's grand finale, decades of dust exploding into the air around him. With the light reflecting on the particles, Léar was engulfed in an ethereal glow, the very portrait of a mad angel from hell.

"What do you need from me, Kirchner?"

Léar smiled. He knew he had hooked Natan. "Call me Léar."

All around them, bells began to ring. Léar looked down at his pocket watch. It was eight thirty A.M. Léar now knew why Natan had wanted to start the meeting when he did. The doors of the church swung open on all four sides of the building and the church parishioners streamed in, crowding around them. Léar looked away for a moment, and when he turned to look back at Natan, he was gone. Despite Natan's distrust of Léar on their first meeting, he knew that he had made the strange man from Romania a believer. Léar had talent at many things, but above all, this was his most profound. He could make anyone a believer, even if the sermon was being delivered by a new pornographer in an old church. Léar walked out of the church as the morning service began, knowing that he would be hearing from his new business partner very soon.

Five Years Later

Montage: We see the years pass, and times change, on the streets of Paris.

The next few years were good to both Nickie and George. They had both prospered and, to their relief, had never heard another word about Léar or the film they had made with him.

Nickie was invited to New York City, where she performed for thousands. For his part, George was becoming one of the biggest stars of stage and film. He played the lead on every stage in Paris. He never had to look for work. Work found him, as did the women.

Nickie had not changed much despite her celebrated status as "the Queen of the Cancan" and Paris's "dancing darling of the Pigalle." She burned through men and money like they were kindling for a much bigger fire.

George never forgot his beginnings and saved every penny he made, only spending the amount he needed to keep up appearances. Somewhere in his darkest fears was the idea that it could all go away with the blink of an eye.

George was always a little nervous. He felt that one day, he would be found out for who he really was. The most terrifying part was that he himself had gotten so far along that he wasn't even sure anymore what exactly it was he would be found out to be.

He never bumped into Nickie; he made a point of it. He knew of her and of her success. He saw her on posters plastered on walls along city streets but never went to her shows. It was actually easy to avoid Nickie Willy. Everyone knew where she would be each night.

Nickie had no reason to seek out George. He was part of a different world, one that she and her friends were not interested in.

In the end, time would be kind to George and less so to Nickie Willy.

Over the next few years, Léar, with the guidance of Bernard Natan and his innovative ideas on distribution, would begin to build a secret empire.

Men were dispatched with briefcases into the night to deliver reels to brothels and underground clubs around Paris. He promoted late-night events and after-hours screenings in theaters across the city. It had begun.

Seventeen Years Later—1929

It was dusk, and the last blue of the sky was turning black. Standing on a street corner in front of an aging and dilapidated Moulin Rouge was a haggard woman. No one would possibly recognize her as anything else but a street vendor of peanuts and cigarettes, let alone "the Queen of the Cancan and Princess of the Pigalle." No, this couldn't be . . . Nickie Willy?

A string tied a box she held in her hands around her neck; it contained a sparse selection of offerings. Her clothes were ripped and dirty, her face black with street soot.

She noticed a man, much older than he had been, his boyish face now more distinguished, lined with handsome wrinkles down his cheeks. He still very much looked like George, and how could he not? His face had grown up with his public. The face he had now was still and always had been that of the famous stage and screen star.

Nickie recognized him immediately and watched as he nervously entered an alleyway, in what was once her part of town. Why would he be here? Like Nickie, the show district had seen much better days and what had once been the place to be was no longer.

Nickie knew this alley well; she had used it to avoid the crowds, escaping out of the back of her theater so she could arrive before all others at her favorite drinking spots and second-tier showhouses. Now it just led to dark storefronts and darker characters, whose homes lay in the shadows of abandoned theaters.

Nickie followed George into the dark alley, through the winding side street that led out into a courtyard in the heart of the back side of the Pigalle district.

On one side of these old buildings was the nightlife of now. A new Paris had grown out of the old, as it always seemed to do, as it had done before and as it would again. The decay of Nickie's Paris, which she had left years ago, was clear. This Paris was unrecognizable and forgotten to her. A world war had been fought and won. Although Paris had been spared from the front lines, over a million men had gone off to fight and had not returned.

A man called Fernand Jacopozzi had built a second Paris toward the end of the war to confuse enemy bomber pilots into attacking empty fields with his amazingly engineered light tricks that mimicked an overhead view of a city alive in night's blanket of darkness. After the war, this "Fake City of Light" had been disassembled by Jacopozzi, who in turn had illuminated the real Paris, starting with Eiffel's tower, taking his unused light tricks and turning them into what would come to define the city for all future generations. In this unintentional world of light, no one's name shined brighter than that of George, the star of stage and screen.

Why was George on a side of Paris he had no use for anymore? The other side, shining and sparkling with electricity, knew him so well. Why would he risk even being seen in a neighborhood

shrouded in darkness and inhabited by the city's most anonymous denizens? Those in the circle that George now ran in would only be here for the most scandalous of reasons for sure. Not to mention his past, which he had always been sure would come back to haunt him one day, somewhere in time.

Nickie no longer knew anyone in Paris. She had spent the years since her return from America haunting the banks of the Rhône from the villages outside of Versailles to the port of Arles, selling secondhand cigarettes as well as her body. It seemed the only person she'd recognized since her return was George, and here he was.

She came off a winding path into an open street she knew. George stood in front of an old movie house silhouetted by its marquee that read:

Jouer Maintenant
La Bonne Auberge
(The Good Inn)

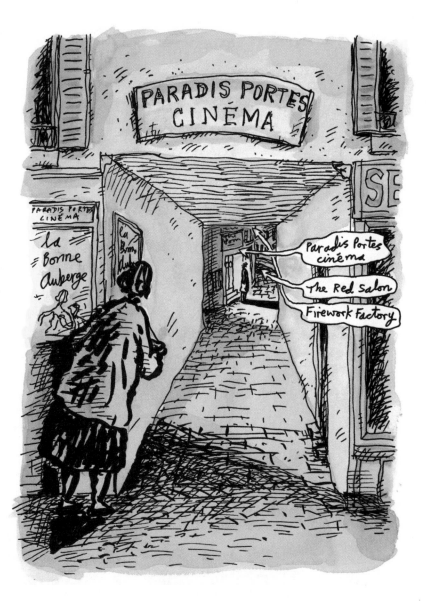

ACT III:
The City of Light

Somewhere between chance and mystery lies
imagination, the only thing that protects our
freedom, despite the fact that people keep trying to
reduce it or kill it off altogether.

—LUIS BUÑUEL

I have always been amazed at the way an ordinary
observer lends so much more credence and
attaches so much more importance to waking
events than to those occurring in dreams . . .
Man . . . is above all the plaything of his memory.

—ANDRÉ BRETON

RIGHT WAY UP

The Mouth of the Rhône

The darkness expands in all directions as Soldier Boy walks aimlessly through a black expanse of nothingness.

On the distant horizon, the black sky seems to end. He stumbles in the dark toward it and comes upon the edge of an intricate forest upside down, in the sky. It is not like any forest he has ever seen. It's made of paper and wood, glowing an ethereal white. A strange thought enters his head as he stares up at it.

"What if I am actually in the sky?"

As soon as that thought enters his head, another follows just behind it.

"Perhaps the ground is right side up, and I am upside down?"

The next thing that Soldier Boy knows, he is walking across the horizontal plane, until the sky becomes the ground, and the ground becomes the sky.

Above him is the black void of sky that once was his ground, and Soldier Boy is standing in a gigantic black-and-white glowing forest set piece.

As he moves through this new world, the pieces that it's composed of move with him, reconfiguring to create new scenery and paths for his benefit alone. The dense two-dimensional forest breaks apart and Soldier Boy finds himself on a riverbank. The water is made up of wood cutouts in the shape of lapping waves and they move mechanically, as if operated by cranks and pulleys.

EXTERIOR/RIVER RHÔNE/NIGHT

Standing on the edge of the strange waters, he looks across to the other shore.

On the other side of the river is an older woman. She looks familiar to Soldier Boy. He waves to her.

She opens her mouth and speaks but no sound comes out. Soldier Boy puts his hand to his ear, but it is no use. The sound does not travel across the water. Instead . . .

All goes black and . . .

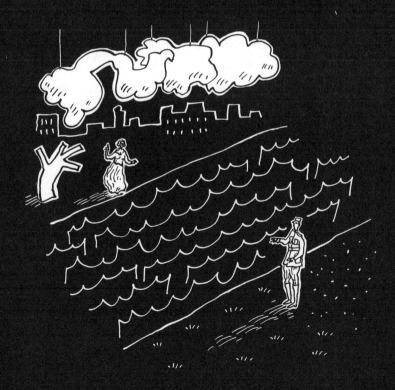

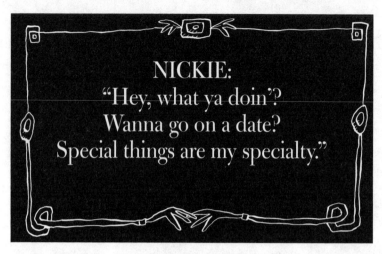

NICKIE:
"Hey, what ya doin'?
Wanna go on a date?
Special things are my specialty."

The blackness disappears and Soldier Boy loses his balance from the effect. He tumbles backward, losing his footing, and falls in between the churning wooden water slats that make up this expressionistic river Rhône. He holds on for dear life as they bob him comically and mechanically up and down. He reaches his hand up to the woman on the other side of the river. It feels like he is being eaten alive by the river, and as he goes under, there is blackness . . .

"Help me!"

. . . and he sinks under and disappears.

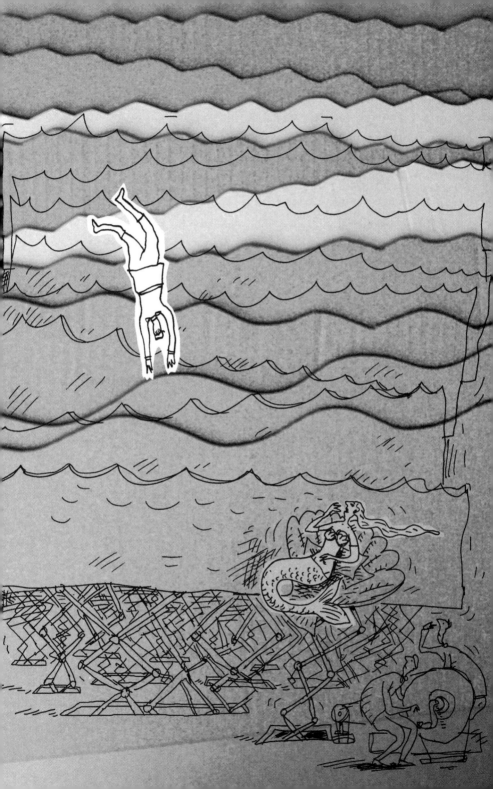

INTERIOR/UNDER THE WOODEN WATER/SAME

Soldier Boy is holding his breath as he flails about under the churning wood-carved waves. However, he is not floating downward underneath the waves, but instead is slowly falling a few feet at a time onto moving panels on turning wheels attached to cranks. As the wheels turn, the wooden slats drop him farther downward. He is caught up in a machine that is operating the wooden waves above. He finally falls to solid ground and looks up.

INTERIOR/BACKSTAGE SET/SAME

Standing over Soldier Boy with an outreached hand is a MERMAID. She is beautiful. She glistens and sparkles, and as she takes his hand into hers, she speaks.

MERMAID: It's all right, you're safe now.

This short serene moment is interrupted by a voice barking orders in her direction.

STAGE MANAGER: Violet! The mermaid scene is over, you have three minutes to change into the pig costume. If you miss another quick-change cue you're out on the street!

As she hurries off, Soldier Boy realizes there are two men in work clothes on either side of him. A third turns the crank that has been operating the set piece Soldier Boy has just fallen down.

Still holding his breath and turning blue, he lets it out and finds that he is not underwater at all. He appears to be under a stage.

SOLDIER BOY: Where am I?

STAGEHAND 1: Where are you? Not where you're

supposed to be, I'm pretty sure of that! How did you get back here?

SOLDIER BOY (pointing up): From up there!

STAGEHAND 2: How did you get up there? You're not supposed to be up there! The show has already started! Who let you in? Did you come in through the stage door?

STAGEHAND 1: I told you we needed to put a man at the stage door.

SOLDIER BOY: I thought I was drowning! I was sure I would perish!

STAGEHAND 1 (laughing): Well that's what's supposed to happen when you fall into water. So I guess we're doing something right. Of course, you're supposed to be feeling like you're drowning from the safety of the audience.

SOLDIER BOY: The audience?

STAGEHAND 2: Yeah, and leaving the actual "drowning" to the actors.

SOLDIER BOY: The actors?!

The stagehands help Soldier Boy stand up and they lead him over to a small winding staircase, up it, and to a giant red curtain. The two stagehands part it in the middle and Soldier Boy stares out into a sea of people, all of whom seem to be staring directly at him. But they are not.

The first stagehand points out to the sea of people.

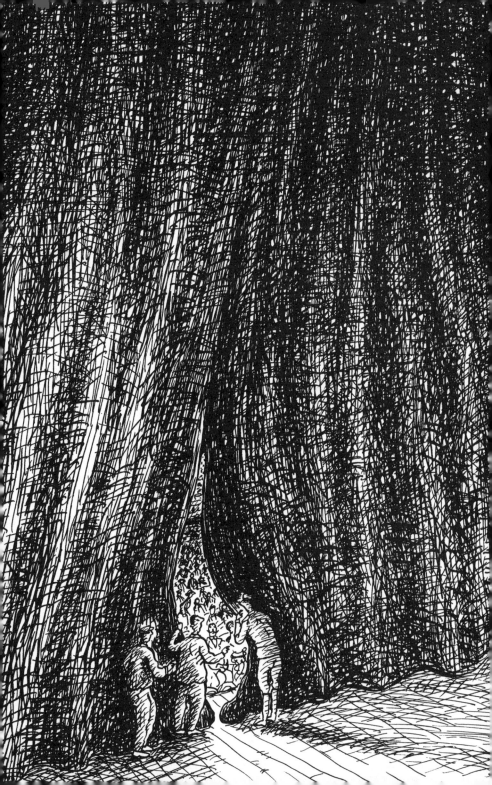

STAGEHAND 1: Audience.

STAGEHAND 2: Where you're supposed to be!

And then to the stage.

STAGEHAND 1: Actors.

STAGEHAND 2: I think he might have bumped his head.

Behind Soldier Boy are SET PIECES FROM HIS ENTIRE JOURNEY THUS FAR. They seem to be a part of the show and ready to roll on- and offstage. From behind Soldier Boy, a voice yells out with a sharp whisper.

STAGE MANAGER: There you are! You're on in three minutes! What are you doing in the soldier's costume? That scene isn't until after the intermission!

He grabs Soldier Boy and leads him down a hall to a dressing room. The name on the dressing room reads, "GEORGE."

SOLDIER BOY (stopping short in front of the door): You're confusing me with someone else. This isn't my room.

STAGE MANAGER: Of course it is, George!

SOLDIER BOY: I'm not George!

STAGE MANAGER: Don't be ridiculous, of course you are. We don't have time for this today. Have you been drinking again? You made a deal!

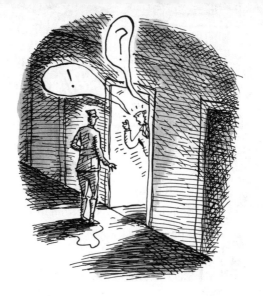

Soldier Boy frees himself of the Stage Manager's grasp and backs away from him.

STAGE MANAGER: What are you doing? Get back here!

The door marked "GEORGE" opens and the Stage Manager looks inside, and then back at Soldier Boy. He looks extremely confused and frightened.

Soldier Boy steps back. He doesn't want to see what the Stage Manager has seen. He knows it can't be good.

The Stage Manager explodes . . .

STAGE MANAGER: *IMPOSTEUR!*

Soldier Boy stumbles backward and loses his balance as he reaches the edge of the stairs that lead down below the theater. He falls down the swirling staircase, picks himself up, and races back to the contraption that he fell down in the first place. Again, the stagehands are operating it and its wheels, sprockets, and levers move upward.

He jumps onto the wooden slats that carried him down and

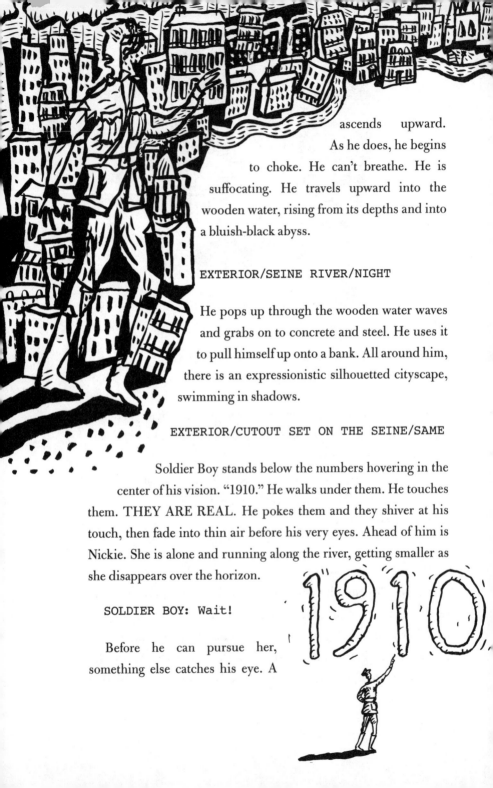

ascends upward. As he does, he begins to choke. He can't breathe. He is suffocating. He travels upward into the wooden water, rising from its depths and into a bluish-black abyss.

EXTERIOR/SEINE RIVER/NIGHT

He pops up through the wooden water waves and grabs on to concrete and steel. He uses it to pull himself up onto a bank. All around him, there is an expressionistic silhouetted cityscape, swimming in shadows.

EXTERIOR/CUTOUT SET ON THE SEINE/SAME

Soldier Boy stands below the numbers hovering in the center of his vision. "1910." He walks under them. He touches them. THEY ARE REAL. He pokes them and they shiver at his touch, then fade into thin air before his very eyes. Ahead of him is Nickie. She is alone and running along the river, getting smaller as she disappears over the horizon.

SOLDIER BOY: Wait!

Before he can pursue her, something else catches his eye. A

man standing on a bridge above the water. This man stares down into the water below with an anger and sadness Soldier Boy has never seen. This is a broken man. This is CHARLES-ÉMILE REYNAUD.

Soldier Boy approaches him and stands beside him. Piled around him are many strange objects that the darkness hides.

SOLDIER BOY: What is wrong, friend?

Reynaud bends down and picks up a handful of the objects at his feet. Soldier Boy recognizes them instantly. They are zoetropes and praxinoscopes in all shapes and sizes, blueprints for unfinished works, moving picture wheels of every type of scenario. They are his inventions and he is dumping them, one by one, into the Seine.

Soldier Boy, furious and panicked, grabs Reynaud's arms and holds them down.

SOLDIER BOY: No! What are you doing?

Reynaud falls over onto his knees in furious tears.

REYNAUD: These things brought me nothing but
sadness and heartache. I have been passed
over. I am penniless. I have nothing. I
gave them the *Théâtre Optique,* but it is
an unkind world to those who try to create
with light. Life is a dark room where light
matters, but no matter how we try, we are
always left in darkness. Let me go!

Reynaud breaks free of Soldier Boy's grasp and continues to hysterically throw his life's work into the black river.

REYNAUD: Everything good will eventually float downriver when the next great thing floats from up it! They were all downriver from me, watching, waiting, and now they float over my achievements in giant grand ships while I drown. Like poor Méliès, who sits alone in Château d'Orly. Ah! The Mutuelle du Cinéma. [Subtitle: A pension fund for filmmakers.] Yes, they have built a home for those who are left in ruin by our much younger protégés who harness our light with the latest inventions, with the best of intentions, alas. Poor friend, he was the first to grow old in our field, and now he is the only occupant of the lonely house for the ghosts of old light.

Reynaud has finished. There is nothing left at his feet. He solemnly stands over the water as they both watch his work float away.

REYNAUD: *C'est la vie.*

Before Soldier Boy can offer any response, he sees Nickie's shadow in the distance crossing a bridge downriver. He runs downstream to catch up to her. Running and tumbling down an embankment, he follows the water in an attempt to get ahead of her.

Soldier Boy runs along the river but slows as he sees ahead of him another set of glowing numbers, hovering midair just above his head.

Again he stops underneath it as he touches the bottom. This time, the numbers seem to giggle as if ticklish to the touch, and then again they fade away. Up ahead is some sort of gathering. Many people stand along the waterfront. Yelling and clapping echo along the set piece walls and the bridges overhead.

COMMISSAIRE VALET, head of the Brigade Mobile, stands at attention, shouting a speech to the crowd.

COMMISSAIRE VALET: We stand here today in
solidarity to send a message to the flesh
peddlers of Paris. You can no longer hide
in your dark sanctuaries of sin. You can no
longer fool the world into believing that
you are undressing some hidden truth. Not
all light illuminates, and the good men and
women of France have seen the light! And
with that said, we send these twenty-five
thousand meters of pornographic material,
confiscated in the many valiant raids
organized by René Bérenger in his honorable
improvement campaign of public morality,
into the dark, where filth should live. It
will sink to the depths away from all matter
of light, forever, down the river, which
will carry it into the sea, for the good of
France and for the good of the people.

On his cue, trumpets sound and a small brigade of soldiers begins to toss reel upon reel of film into the river.

FLASHES BURN and send SMOKE into the sky from the many cameras held by the press corps, who have all been strategically assembled for this political "street theater." It seems all the assembled press is well aware of the ridiculous scene that has been set up for them to report back to the public.

One journalist steps forward and shouts out to the Commissaire.

JOURNALIST: Will there be more public displays such as this to come? Will Père-la-Pudeur seek out similar fates for others as he did the actors and directors of the Ciné-Actualités, the company Bernard Natan founded whose thirty-one reels of film are now floating away from "the good men and women of France"?

COMMISSAIRE VALET: The Seine tribunal will punish any individual or group that creates an abomination to the eye or affront to morality. I do not know what future steps will be taken, but I can tell you that the military is ready to wage war on this enemy at its commander's call to arms.

Soldier Boy stands in the background, watching the scene unfold before his eyes. As he watches, the condemned film floats downstream, into the darkness. There is another glowing number. It hovers above the bobbing canisters and knotted film as it floats away with them.

Soldier Boy pursues it, running, attempting to catch up to it. As he gets closer, the numbers come into focus.

Almost out of breath, he rounds a bend and the numbers fall into a drain out of sight, next to a staircase that leads to the street above. The film, however, has stopped up the drain and REAL WATER begins to rise. It flows over the wooden cutouts of water, spilling onto the river walkway and over Soldier Boy's shoes.

Looking up, he just makes out Nickie's silhouette as she turns and disappears above.

He runs up the stairs and finds himself at the entrance of a dark alley with tall walls on either side. Nickie disappears into its darkness.

EXTERIOR/ALLEYWAY/SAME

The thinnest alleyway in the world separates two blocks of buildings, and the alley looks like it goes on forever.

A flame lights a doorway in the distance and Soldier Boy squeezes his way through the small space toward it.

On the walls are posters, plastered impossibly high, far above anyone's reach. They seem to be descending in order of events

that happened years before to events that happen in years to come. They are all advertisements for theatrical pieces. On the left wall are posters for George's plays and on the right are posters promoting Nickie and her act.

As Soldier Boy stumbles and squeezes as best he can into the confined space, he moves toward the light. As the posters progress they move from featuring the grandest events and venues to the most run-down third-tier theaters, performers, and showcases. By the time Soldier Boy reaches the door, a small, torn, and hastily drawn poster reads:

LIVE GIRLS
in only flesh!

And in small print below it . . .

with NICKIE WILLY'S DANCING GIRLS

Looking back down the alley to where he came from, a small army of shadows is running toward him. They are shouting and pursuing him.

Soldier Boy pushes the alleyway door open and goes inside.

INTERIOR/BACKSTAGE SHOW PALACE/SAME

It is dark and warm and Soldier Boy stumbles, reaching out for something to get his bearings. His hands grab on to curtains and he carefully pulls them apart revealing another, much smaller theater. This venue has clearly seen better days. It's falling apart.

In the audience sits one man watching the stage. Soldier Boy

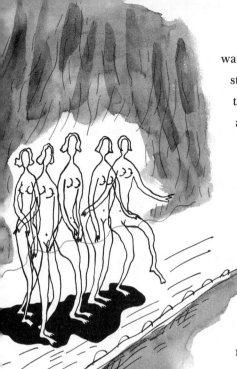

watches as five naked women stand silently in front of the virtually empty house and its rickety rows of old empty seats. One of the women timidly steps forward and speaks for the others.

NAKED WOMAN: What about the music?

CLUB OWNER: What about music?

NAKED WOMAN: What are we to dance to?

The Club Owner looks up at her, disgusted, and then begins to clap his hands together.

Through the slit in the curtains, Soldier Boy watches, transfixed. A pretty young girl steps up next to him and stares out numbly at the scene. She whispers as they both watch.

YOUNG DANCER (singing a cappella in time with the man's clapping): *She's prepared now for the dancing but he isn't even glancing. She requests a little music, but he*

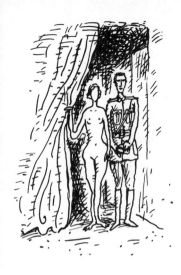

says, Please, no excuses. That's how you get your chance, sonny, working for Mr. Milk and Honey.

SOLDIER BOY: Why do you do it?

YOUNG DANCER: A girl has gotta eat. Some folk have brains or brawn. We've got curves and feet.

The Young Dancer takes Soldier Boy's hand.

YOUNG DANCER: Come on.

SOLDIER BOY: Where are we going?

YOUNG DANCER: You're here to see her, aren't you?

She leads him farther backstage to a ladder that ascends toward a loft above.

YOUNG DANCER: She's up there. She doesn't dance anymore. She can't. She's probably older than you remember. Try not to be disappointed. They all come looking for her. Some don't mind what they find, as long as they can say they had their night with Nickie Willy. But hurry, she's already started her drink for the evening, so she won't be at her best for much longer.

The Young Dancer steps backward and disappears.

Soldier Boy begins to climb the ladder. Just as he peeks over the top, he sees the back of a woman sitting by candlelight at a vanity mirror. She is pouring a glass of dark liquid.

Soldier Boy is YANKED BACKWARD off of the ladder onto the floor. He looks up at a very angry Club Owner, who grabs him by his jacket collar and throws him up against the crumbling brick wall.

CLUB OWNER: How many times
do I have to tell you pricks
that you gotta go through me?
[singing a cappella] *THAT'S how
it's gotta be, sonny, dealing
with Mr. Milk and Honey!*

SOLDIER BOY: Sir, you're making a
mistake, I was just, you're going to hit me
aren't you . . .

Before Soldier Boy can say another word, the Club Owner
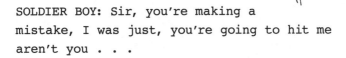
punches him square in the face.

EXTERIOR/STAGE DOOR/NIGHT

Soldier Boy is thrown headfirst back into the alley. The door slams behind him. Before he can start to collect his thoughts he sees the shadows of angry men running toward him, this time from the opposite direction. He runs back toward the alley entrance. He makes his way toward the stairs that lead back down to the river, barely able to see in front of him from darkness and blood gushing from the angry gash on his head, rudely interrupted from healing yet again.

He reaches the alley's mouth and turns to see the gang of shadows chasing after him come into the moonlight, which now shines through the thin

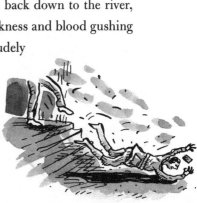

opening between the alley walls above. They are all dressed like him. They are soldiers. He recognizes them. Leading the pack is the most familiar face of them all. It's Roussou. He doesn't look angry. He looks concerned.

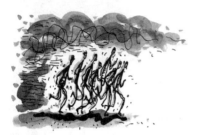 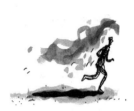

ROUSSOU: Wait! Stop! Soldier Boy! You're going the wrong way!

EXTERIOR/ALLEYWAY RIVER STAIRCASE/SAME

Soldier Boy falls and tumbles down the staircase landing to the Seine.

He descends deep into the black water. The loose film stopping up the drain snakes around him and he becomes entangled in it; his limbs get wrapped up, and it pulls him deeper under the water. He looks up to see the dim light of the surface getting darker and darker until there is nothing to see.

A voice. It is Nicole's voice.

Nicole (offscreen): Do you know what angels are made of, Soldier Boy?

Far above him on the surface, a bright LIGHT SHOOTS DOWN INTO THE DEPTHS, bathing his body in an angelic GLOW.

EXTERIOR/RIVERBED/NIGHT

Soldier Boy shoots up to the surface, as if he has been pushed upward by his feet thanks to an incredible force.

He flips and flops over onto the riverbed like a condemned fish, soaked and coughing up water. He is back out in the open, in the dark, glowing forest. Above him stands Nickie. Haggard, overweight, and sickly, she looks down on him as he catches his breath.

SOLDIER BOY (coughing): It is you.

NICKIE (singing a cappella): *Hey, what ya doin'? Wanna go on a date? Special things are my specialty.*

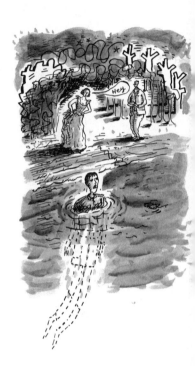

SOLDIER BOY: How did you get here?

NICKIE (singing a cappella): *Like you, I'm born to roam. What have you come to find, hanging out at the mouth of the Rhône—a low poke every time.*

SOLDIER BOY: What are you doing here?

NICKIE (singing): *I'm waiting at the shore, but you're not my average client. (Are you?) Still, I am the one who will give you more, a low poke every time. A grain of red sand came, and fell into my eye, came all the way from Africa, just to make me cry. Just to make me try. J'appel la Tramontane,* and here is the reason why, that's the howl can make ya go insane, but I just hang my head and cry.*

* La Tramontane, n: A strong, dry, cold wind from the north. The continuous howling noise of the Tramontane is said to have a disturbing effect upon the psyche.

Once there was this one, that I loved, took my troubles far away. Hear the bells far above, and the voices of the santonniers.

But now I'm hanging out at the mouth of the Rhône—a low poke every time!

Out of the woods a "gentleman" approaches Nickie. This is clearly a common sight in these parts. He looks around nervously, but before he can change his mind . . .

NICKIE (to the man): Come here. I'm actually really nice. I'm a creative type.

She takes his arm and turns, walking away with him into the dark, leaving Soldier Boy alone by the riverbed. He is wet and shivering cold.

He stands and looks out in the direction they strolled off in.

SOLDIER BOY: No, wait!

He pushes angrily through two-dimensional glowing bushes and brush. They crash down flat onto the ground as he bulldozes through the fake world. The set is changing before his very eyes on this life-size stage.

And then . . .

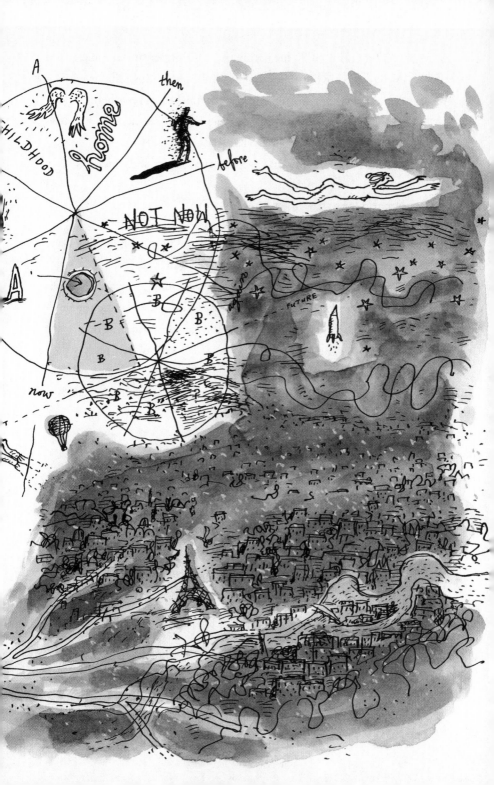

The entire SET breaks apart, whirling away on rollers and up into the air on pulleys all around Soldier Boy. The event is a dizzying, dazzling display that, when finished, reveals behind it not a backstage concrete wall or another surreal set piece, but instead THE REAL NIGHT SKY OF PARIS.

The Paris of Soldier Boy's memories. All around him.

EXTERIOR/PARIS/NIGHT (in color)

Soldier Boy's body gives out. He lands on his knees, looking up at Paris spread out in all directions around him.

Shaking from excitement and overwhelming confusion, he looks up into the sky to see it is lit almost as bright as day by the city's twinkling, warm glow. It is unlike the backdrops in the dreamscape he has just wandered through. This scene is absolutely *real*.

Soldier Boy has arrived in Paris. It is early evening, and just above his head are four more floating white numbers preceded by a single word.

CUT TO BLACK

A MAP FROM <u>HERE</u> TO THE <u>END</u>

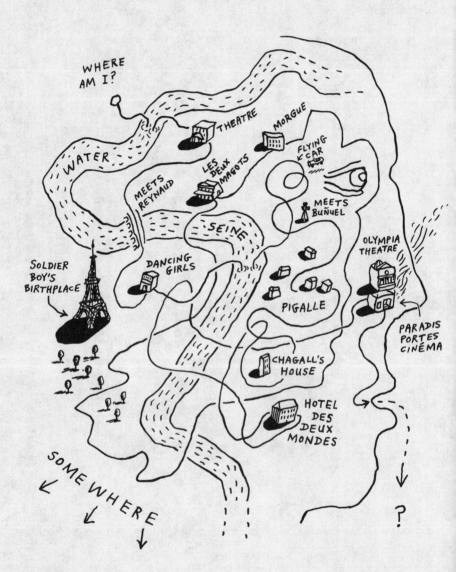

WHERE AM I?

WATER

THEATRE

MORGUE

FLYING CAR

LES DEUX MAGOTS

MEETS REYNAUD

MEETS BUÑUEL

SEINE

OLYMPIA THEATRE

SOLDIER BOY'S BIRTHPLACE

DANCING GIRLS

PIGALLE

PARADIS PORTES CINÉMA

CHAGALL'S HOUSE

HOTEL DES DEUX MONDES

SOMEWHERE

?

In the Pigalle

O ver black, heavy breathing of two, a man and a woman. A climax. Silence.

CUT TO:

INTERIOR/INTERROGATION ROOM/DAY

Soldier Boy sits across from Roussou, who, despite decomposition, appears to be in good spirits.

SOLDIER BOY: Roussou? You're alive!

ROUSSOU: Not very much, I'm sad to say. It's much harder to keep myself together these days, but otherwise, I'm fit for duty.

His jaw cracks, sways back and forth unhinged on his face, and then falls to the table. Roussou casually picks it up and puts it back on.

SOLDIER BOY: You're dead?

ROUSSOU: Dead-ish. Yes. [looking down sadly
and then shooting back up with a warm smile]
But aren't we all? As for me, it seems I'm no
angel. So if I am to stay here longer than
I was intended to, I must slowly watch as my
skin peels away from my extremities. Only
angels have the luxury of vanity. Do you
know why that is? Do you know what angels
are made of, Soldier Boy?

Before he can answer, something happens.

On the far wall behind Roussou, a small pinhole appears. A light
flickers through it. Another appears, and then another. Dozens of
tiny holes with tiny flickering lights spray out directly onto Soldier
Boy, covering him from head to toe. None of this seems to faze
Roussou.

ROUSSOU: You look well. You're glowing. What
have you to report?

SOLDIER BOY: Report?

ROUSSOU: Your mission. Your special mission?
Although it is profoundly wonderful to see
you, there is business to attend to.

SOLDIER BOY: Well, Roussou, they didn't
give me much direction. None really. I went
wandering and I found myself in some pretty
tricky situations. I met a girl.

ROUSSOU: Ah, a woman! Was she pretty?

SOLDIER BOY: Which one?

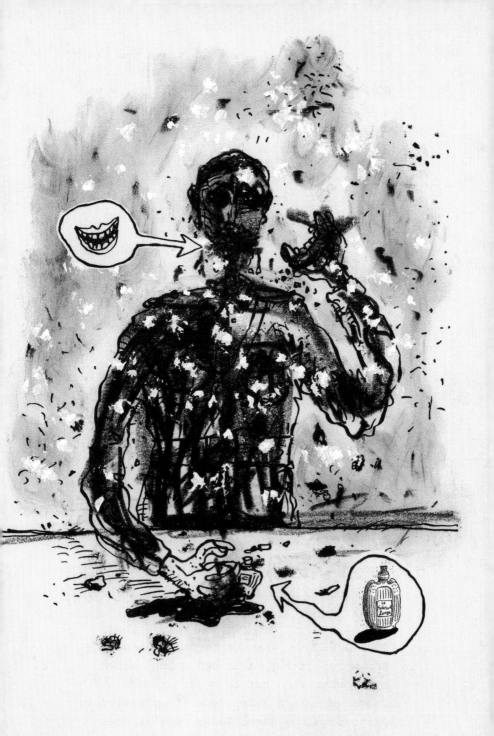

ROUSSOU: My friend, how many have you had?!

SOLDIER BOY: There were two—that is, when
I looked through the hole. And so then I
entered it.

ROUSSOU: As any man in his right mind would!

SOLDIER BOY: There I was, again, and there
she was, again. So I pursued this other
woman in hopes of finding this other me.

ROUSSOU: Very good. This is exactly what I
would have done. And then?

SOLDIER BOY: It has brought me to Paris.
Where we are, aren't we?

ROUSSOU: You are, my friend. I am nowhere,
but once your mission is complete, we can
all go home.

SOLDIER BOY: When will that be?

Roussou takes a shining white bottle out of his coat pocket, opens
it, and drinks from it.

ROUSSOU: Very soon I hope.

SOLDIER BOY: Roussou, what is that you are
drinking? I have seen that bottle before, I
think. Maybe I dreamed it?

ROUSSOU: It is what is keeping the dirt
and worms at bay, although I must watch
my footing when not on solid ground.
Those worms are relentless. They call this
concoction the Angel Maker, but it doesn't

work very well on those of us who aren't fit
to be angels.

SOLDIER BOY: Do I know what angels are
made of?

ROUSSOU: What's that you say?

SOLDIER BOY: You asked me if I knew what
angels are made of. I feel like I should
know the answer.

ROUSSOU: Soldier Boy, remember the mission
at hand. Paris can be a very intoxicating
cocktail, unlike this meddlesome milk. Be
sure to drink it slowly. It will try to make
you forget what you are looking for and then
you will sip it all the more because you
realize how parched you truly have been. All
we are saying is . . . All I am saying is,
don't forget about me or the rest of us.

SOLDIER BOY: I couldn't. I wouldn't.

ROUSSOU: All I am saying, my friend, is, it's
Paris, things might get . . . weird.

The beams of light spread out, covering the entire room and
washing everything out except Soldier Boy, who covers his eyes so
as to not go blind.

CUT TO:

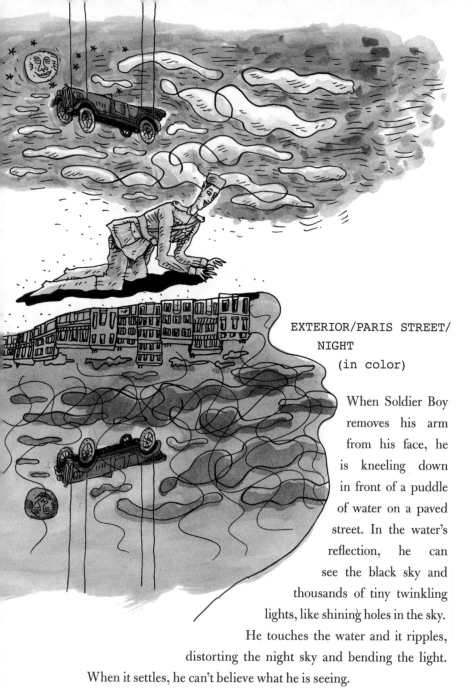

EXTERIOR/PARIS STREET/
NIGHT

(in color)

When Soldier Boy removes his arm from his face, he is kneeling down in front of a puddle of water on a paved street. In the water's reflection, he can see the black sky and thousands of tiny twinkling lights, like shining holes in the sky.

He touches the water and it ripples, distorting the night sky and bending the light. When it settles, he can't believe what he is seeing.

Flying across the sky is an automobile. He looks up just as it passes overhead. The night sky hides the steel wires that hold it up,

attached to a crane that carries it over the buildings and around to the small cargo ship docked along the Seine awaiting it.

It whooshes away out of sight over a dazzling, sparkling sign attached to a building on the corner of the street that reads:

Gaumont Palace Theatre
présentation Du cinéma Parlant
(introducing the Musical Talking Cinema in COLOR!)

IRENE BORDONI
dans
Paris!

Soldier Boy laughs and smiles like a little child without a care in the world.

Music from nowhere swells and fills the streets, exploding into a deep and grand orchestrated song.

(Music continues through the entire final act.)

SOLDIER BOY (breaking into song): *They did it. My God, they really did it! They promised, and they said it, and they did it, they really, really did it! Flying cars and singing stars, they delivered it! If this is a waking sleep, or a living dream, I don't need to know. If I'm dead don't revive me. If I'm sleeping don't ever wake me. If I am sick, then I wanna be sick all the time.*

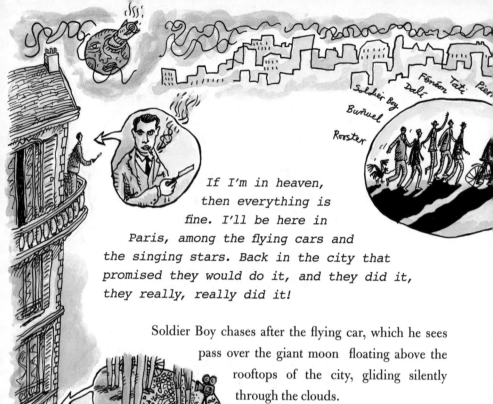

> If I'm in heaven, then everything is fine. I'll be here in Paris, among the flying cars and the singing stars. Back in the city that promised they would do it, and they did it, they really, really did it!

Soldier Boy chases after the flying car, which he sees pass over the giant moon floating above the rooftops of the city, gliding silently through the clouds.

Falling over himself, he tries to run while looking up into the sky following the flying car through the maze of small twisting pathways and alleys between the buildings.

EXTERIOR/COURTYARD/SAME

He comes upon a seemingly quiet courtyard. Looking up at the sky, he searches for his flying car, but it is gone and only the giant moon remains. He looks up at a balcony just above the street. A man stands on it staring into the bright silver circle in the sky.

Soldier Boy yells up to him.

SOLDIER BOY: Sir, did you see it? Did you see

 it? They did it! They really, really did it!

The man is sharpening a shiny blade in his hands. Soldier Boy looks up into the sky to see a cloud slicing through the full moon. It doesn't seem like the man above can hear him.

A scrawny man pedals by on a bicycle and falls off of it in front of Soldier Boy. He doesn't get up. Soldier Boy walks over to him and tries to lift him up, but he appears to be dead. Soldier Boy pokes at him.

Soldier Boy turns him over and his eyes pop open. Soldier Boy is startled and falls backward, hitting his head. He is out cold.

PIERRE (THE MAN ON THE BICYCLE):

"George? Are you all right? Good old George, giving us all a good laugh at his own expense! Everyone come see, my brother George has paid us a visit! And that soldier's costume? What an entrance!"

As Soldier Boy comes to, a small crowd has congregated around him. Standing in front is the man with the bicycle. He is talking, but Soldier Boy cannot hear a word he says.

Another man comes up from behind the man on the bicycle. This is the man from the balcony. He holds the same sharp and shiny blade in his strong hand menacingly as a cigarette dangles from his mouth.

PIERRE:
"Look, Monsieur Buñuel,
George has dropped in on us!"

As Pierre speaks, not a word comes out of his mouth. Buñuel leans down over Soldier Boy and says . . .

BUÑUEL:
"In the literary sense. He has. Splat on the pavement, centered in my shot. Fell down from the tiered private upper box seats far below the children of paradise to swim in the muck with us dirty peasants. Very well. The shot is in the can and George has blessed us with his presence, no doubt to relieve himself of the tedium of bourgeois boredom. Friends, let us not disappoint him!"

Soldier Boy is helped up by his seemingly old friends, who all pat him on the back and poke at his silly costume. This is the crew of the film shoot that he has wandered into. All around he can hear every sound the city has to offer save for the sound coming out of the mouths of his company.

SOLDIER BOY: I can hear myself, but I cannot
hear a word you say when you open your

mouths. I SEE your words, but I do not hear them!

The film crew surrounding Soldier Boy begins to break down the night's equipment while Pierre and a few other friends break into uncontrollable laughter at what Soldier Boy has just said. It is as if he has told a wonderful joke.

SOLDIER BOY: This George, who is he? What do you know of him?

And then . . .

PIERRE:
"George has come to us with a head start tonight!
For how long have you been out already?
It's quite early for you to have already forgotten your
dear friends and gone deaf or blind, or both!
Good ol' George!"

CUT TO:

And so then off they went with plans in place,
to remind their forgetful friend all his old friends' tastes.
To show the celebrated star of Paris's stage,
what he's been missing, on his rise to fame,
a night that money just couldn't buy,
these people who have made a mistake,
for this is not their famous George.
But a lost Soldier Boy.

The crew is all collected;
they congregate in a small square in the Pigalle.
Once they all heard of the plans, and the company that they
would be keeping,
there was no one who would miss such an epic night.

From the film shoot, no longer atop his bike,
Pierre is in the lead, as is his leading lady,
who is kissing Soldier Boy's sleeve.

First to join the party is Félix Fénéon, surprisingly on time, probably
keeping count of minutes, Pierre suggests to Soldier Boy, with his
latest time-bomb piece.

He's escorting Irene Bordoni; she is the star of the latest musical
playing at the cinema down the way,
a beautiful French-born actress
who has made it in the USA.

Next to arrive is Jacques Tati; he isn't anyone yet,
but he has big plans, so he fits right in among this set.
He strolls up to the bunch as yet another body arrives,
a friend of the director's named DALÍ,
who has a live rooster at his side.

Off they go into the night. The first stop is very close
but also quite out of sight.
Down an alley, through a door, up a staircase, and then down two
more.

Drinks are served, the color green;
the place is packed, and sweet smoke fills the air with nowhere to
escape.
They pour the liquid into Soldier Boy's cup,
he drinks it up,
and they fill it over the brim,
again and again.

But there is no time to
waste, there are still
many more stops,
so they have to
keep up the pace.
Back down the
alley, through the
door, down the
staircase, and then
up two more.

They are walking
so fast that Soldier Boy
loses his step, toppling
over Dalí and his rooster,
whose name, he is told, is
Gissette.

Up into the air the rooster flies
while Dalí shouts, "Get back
here, you dirty cock, you!"

Everyone watches as it hovers above,
while Dalí screams insults and the others try to talk it down from its perch.
It has settled on a windowsill three stories up, of a flat being rented
by a friend of Fénéon's, who shouts out, hoping he will hear,
to this painter named Chagall whom he met through Seurat,
whose neo-impressionist paintings he championed by naming the lot.

He shouts up for his peer to help out
and catch the wild rooster that's flailing about.

The window frame opens and a hand grabs its leg,
but the bird is a fighter and flies way up high,
carrying poor Chagall out until he is almost floating in the sky.

Getting control, he pulls the bird in, and brings it down to the street,
and joins the party,
which is already on to the next scene. The next stop is something peculiar,
an activity that only these strange men knew;
it seems that George came up with the plan when he refused to go
to the parts of town that other gentlemen do.
In lieu of the usual "late-night entertainment"
he had found a way to visit the latest peep show at a more civilized venue.

They all stand in front of the Hotel des Deux Mondes, and the men
serenade the women with their usual song.
Which translates in English to . . .

ALL SINGING:

"In the Hotel of Two Worlds. We will peek through your holes, and see the kind of things that nobody does. What goes on at Hotel des Deux Mondes, only we will see, with every peek we sneak, our eyes will capture, secret stories, from this world and the next, from here to the hereafter."

This is always the part of the night the ladies will not entertain,
so they wait in the lobby drinking cheap champagne.
The men push Soldier Boy up a grand flight of stairs,
down a long hallway, where the guest rooms line the walls.
They continue their drunken singing as they each march
down the halls,
taking their stand, in front of a door that they choose,
lined up along the wall.

ALL SINGING:

"What will we see, oh what will we see, oh, Georgie, our most prudish friend, what will we see through your peepholes tonight!"

Soldier Boy watches as the men all bend down
and look into the rooms, into the other world on the other side
of this aptly named hotel. Fénéon is the first to describe what he sees:
an older man is crying onto a letter that he reads.
He assumes that he has been left by his much younger bride
who ran off with his stepson,
who both soon will die.

Next is Pierre, who explains what he sees:
a woman stands naked, above a man on his knees.
She stares at herself in a mirror while he kisses her feet.
She walks away from his advances as he arrives at her thighs.
He pants like a dog as she wishes him a good night.

Tati sees a musician just returned from his nightly session,
preparing a bath while starting a phonograph.
Now naked, he carries his trumpet under his arm,
and sitting down in the tub, he begins to play along.

Buñuel watches Soldier Boy with a look of concern;
George doesn't seem like himself, he hasn't even looked in his hole.
He motions for Soldier Boy to look in on the show.

BUÑUEL:
"Did you know that the peep show has played a most vital role in developing the point-of-view shot and thus has made it so, we can tell much longer tales than ever told before? And so, all of us who make these moving pictures owe a great deal of gratitude to the doors that have been opened from looking into keyholes."

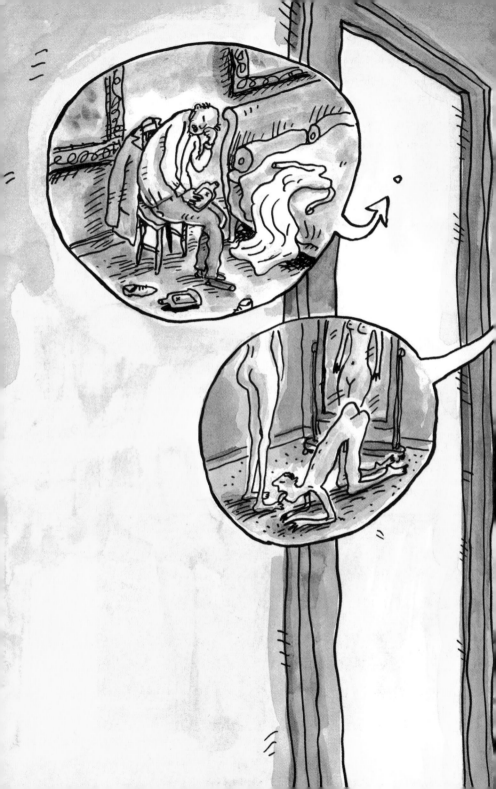

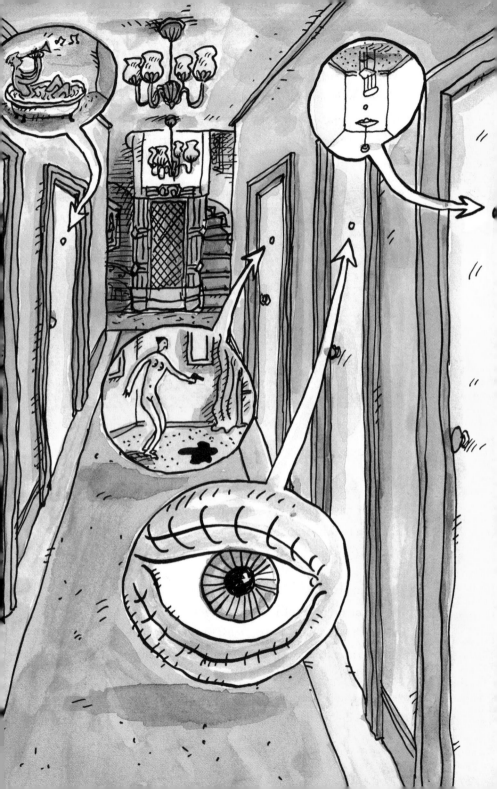

The director then bends down and gives it a go;
a woman is dancing with an invisible man,
and then pulls out a pistol
and shoots him in the head.
Soldier Boy peers through the hole in his door; to his surprise an
eye stares right back at him.

PIERRE:
"What have you found, tell us,
Georgie boy. What do you see?"

SOLDIER BOY: I'm looking at nothing. Someone
is looking at me!

He backs away from the troublesome view;
the others have joined him and each take a turn.
Each man returns with the same upsetting news:
no one is there, just a room with a view.

They then make their way to the basement salon,
where something peculiar is always going on.
They each take a peek into the most secret room in the place;
tonight is no exception, you can see it on their delighted faces,
peeking through the keyhole on this very night. Savate is this
evening's entertainment,
which is a French game of foot fights.

Off they go to the next stop on the way
toward the final surprise, which is a secret they save.
Into the streets the whole caravan screams,
riding the city like it's a roller coaster,
up then down, to the darkest place in Paris at this time of night.

Before the picture shows, this was the late-night attraction to beat,
but now no one goes here,
except for those who care for the dead, are looking for thrills,
or are just wrong in the head.

INTERIOR/PARIS MORGUE/NIGHT

The morgue is located within a short walk of their next destination,
Les Deux Magots!
The bodies are lined in rows up and down;
the revelers walk them in a somber silence until . . .

Fénéon as usual is ready to entertain, by standing on the corpses'
tables and stating a claim,
that death is something the living
should embrace,
as the living since birth are from
the very start
well on their way to the very
same place.

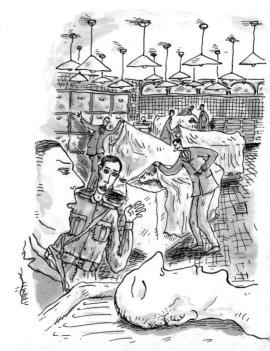

Pierre steps up next to Soldier
Boy, who appears to look very
sad and has since gone pale. He
puts his hand on Soldier Boy's
shoulder and speaks under his
breath.

PIERRE:

"When the film ends, be it *un drame, un comédie, un aventure,* if there is life, or there is death, despite a happy ending, or a sad finish, we are all left in the dark when the picture ends, but wherever you go, be it heaven or hell, you will most certainly always have friends."

SOLDIER BOY: Please, oh, please, if you truly are my dear friend, take me away from this place.

EXTERIOR/PARIS STREETS/NIGHT

They ascend up out of the darkness,
onto the brightest Paris street,
brighter than any other,
from here to where the sea and the Seine both meet,
on to Montmartre, down the boulevard des Capucines.

And there in the distance, touching the sky, is the tower that Eiffel built,
and all around Soldier Boy, the streets are alive,
the lights blinking almost seem to electrify,
the very atoms in the air, and the colors, the colors everywhere,
so rich and vibrant, one might think one could taste them.

Soldier Boy suggests such a thing to Tati,
who quickly tests the theory on a piece of poster
that he rips from the wall, licks and then eats.

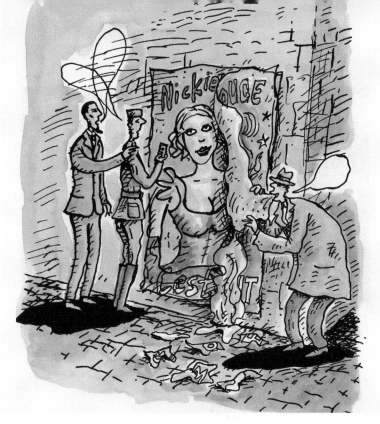

Soldier Boy stops short and sees the image torn in two:

it's a woman whom he's sure he once knew.

He pulls out of his pocket, the picture from Pirou,

that he bought off of a peasant,

what seems like years ago.

Yes, it is her. The woman from the picture,

the woman whom he pursued.

She is so much older now that he almost did not connect,

that this was the once-famous Nickie

whom he had seen through the Good Inn's hole.

Fénéon has stopped and watches his companion,

wondering about much the same thing as the others:

There is something odd about this George, but what?

Now standing beside Soldier Boy, he speaks . . .

FÉNÉON:

"She is no longer living in the Paris lights. Only her image remains. But oh, back then, she was the light that lit this entire city. Now electricity has taken her place. But there is still a way to see her light up the darkness; if you want we can take you to her. How about it? There is a place where she still lives."

Fénéon speaks softly, wary of passersby; out in the open this man seems less at ease.

FÉNÉON: "Shall we go there?"

SOLDIER BOY: Oh, yes! Please!

CUT TO:

INTERIOR/LES DEUX MAGOTS/NIGHT

On to the next stop that was in the plan,
Pierre, Soldier Boy, and the others make their entrance so grand,
and take over the best seats in the house
next to the dancing girls and the piano man,
with his three-piece band.
On top of the stage, is the latest take on the Paris cancan.
Everyone is here tonight, everyone is out and about.
First to join them at their table is Alice Guy,
the first woman director, who has since retired.
Following Alice is Jacques Prévert,

a celebrated young poet
and member of André Breton's Rue du Château group.
Across the room sits the son of Renoir,
who sold some of his father's paintings
to finance his latest flick.

The food and drinks arrive, and Soldier Boy eats until he is
satisfied.
Never has he felt like this, so full, and so alive.

He impresses almost all attending with his knowledge of moving
picture history
and all the facts that he's collected.
All but Félix Fénéon have taken to their new George,
but Félix senses there is something off about their little Soldier Boy.
Suddenly, Jacques stands up drunk and announces that he has
something to say.
His friend André Breton has pronounced this, and he wants
everyone to listen,
because it is a matter of fact that

"the man who can't visualize a horse galloping on a tomato is an idiot!"

The night is capped with song and dance,
a digestif, and in the back parlor, a game of chance,
where cards are dealt around a table.
What Soldier Boy loses is won by Pierre,
who shares his winnings with everyone there.

As Soldier Boy walks back across the wide open space,
passing the singing and the dancing,
heading for his new friends, at the best table in the place,

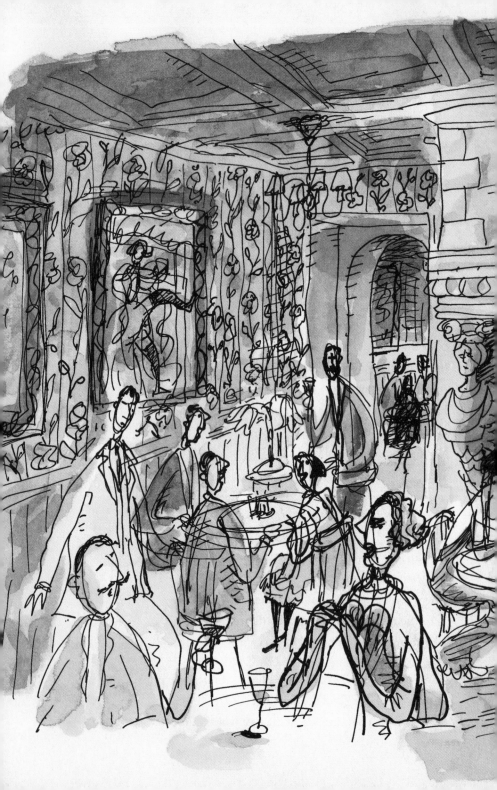

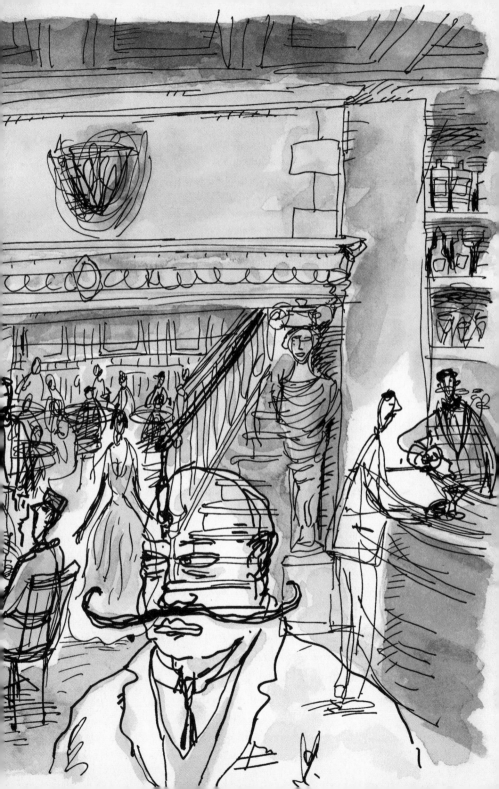

a hand grabs his arm and he jerks to a stop,
and looks down at the table where his arm has been caught.

An older man whom he seems to recognize,
by the shape of his head
and the curls on his mustache's sides.
But still he can't place the face, which he was having a hard time doing,
because he saw it through a hole,
in a different time and place.

Léar has been dining far across the room, studying Soldier Boy,
while catching up with his special dinner guest.

Bernard Natan has come far from his Romanian days;
just that very week he purchased Pathé and now owns the largest film
production company outside of the USA.
As Léar smiles and nods at all his old partner's newest exploits,
he is wondering if he will ever rid his mouth of this most bitter taste.
Why is he not in his old business partner's shoes,
walking on air, after paying his dues?
A little film he believed would bring him fortune and fame,
shot his lead actor to stardom and made Natan his name.
But no one wants to remember
the film that is to blame.

What a reunion, this couldn't be a coincidence;
Léar has a few words to say to George, who has forgotten the man
who gave him his chance.
And now that actor is standing in front of his face,
wearing a costume for a film he was in,
about an inn, from a plot that Léar did spin,
although even he would admit, it was thin.

Has Natan planned this little twist?

Suddenly Léar's worst returns, and he is sure that the joke was planned,

at his own expense.

And then he speaks . . .

LÉAR:

"Why, George! You look so fit, despite your age, you could still play anything that you were offered! It's been so long. I almost forgot, how good you look in a soldier's costume!"

SOLDIER BOY: Costume? These are my clothes. I've worn them since I left my post. Do we know each other? I'm afraid tonight has taken half my wits!

And then Léar laughs and speaks again.

LÉAR:

"Ah yes! But lucky for you, even a half-wit can play a soldier if he knows how to screw!"

And then Soldier Boy pulls back his arm,
stepping away, both offended and alarmed;
who is this man speaking to him so unkindly,
what has he done to him, in this or in some other life?
Léar then stands up prepared for a fight;
Natan grabs his arm, holding on tight.
Only too schooled in this man's brutal force,
he doesn't want talk of a scene,
especially with all that he has to lose.

Soldier Boy backs away and returns to his crew,
while Léar watches them pay the bill and head for the street.
Léar turns to Natan with apologies
and sits back down in his seat.

Natan clears his throat and speaks.

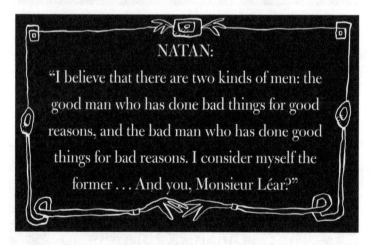

NATAN:
"I believe that there are two kinds of men: the good man who has done bad things for good reasons, and the bad man who has done good things for bad reasons. I consider myself the former . . . And you, Monsieur Léar?"

Léar smiles at Natan and then pats his mouth with his napkin and places it gently on the table before he quietly responds.

"I am just a grain of red sand, my old friend.
I travel on the sirocco wind,
blown all the way from Africa,
where I meet with La Tramontane.
From there I travel through the Rhône Valley,
where I find these lost souls—my creations;
they travel through light, which is itself quite a feat,
but unlike light, the wind can go where light cannot,
to that place where the truth always hides:
into the dark."

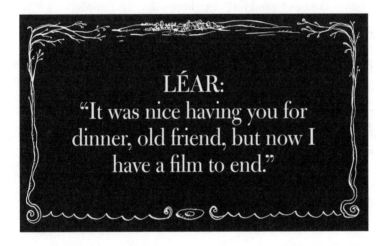

LÉAR:
"It was nice having you for
dinner, old friend, but now I
have a film to end."

CUT TO:

EXTERIOR/STREET/NIGHT

The group is thinning.
The ladies have said their good nights,
but the evening is not yet over.
There is still one more stop to make.
Leading the way is Fénéon, walking at a brisk pace;
Buñuel can barely keep up,
with his cigarette hanging off his face.

Up the boulevard de Bonne Nouvelle
to passage de l'Opéra
and through a little alley into a courtyard
where, once upon a time, a magician named Méliès
had a cinema in the open air.
Across a connecting courtyard
past a building that once was
a little cinema founded by none other than Monsieur Léar and
Monsieur Pirou.

Past the famous Grand Café, in whose salon the Lumières
projected their proudest day.

Finally, they turn a corner onto the boulevard des Capucines,
in the Ninth Arrondissement,
to the number twenty-three.
Above them, lighting up the night,
is the name of another once-famous site:

Olympia Theatre

Here, Fénéon explains, is where the founder of the Moulin Rouge
built a movie theater, the biggest at the time,
with a small basement theater below,
also owned by Monsieur Léar and Monsieur Pirou.

Once the grandest show palace,
where everyone performed,
even Nickie Willy, before her light went out.
But now the place has seen better days,
the entrance to it has been razed,
all that's left is its grand old sign,

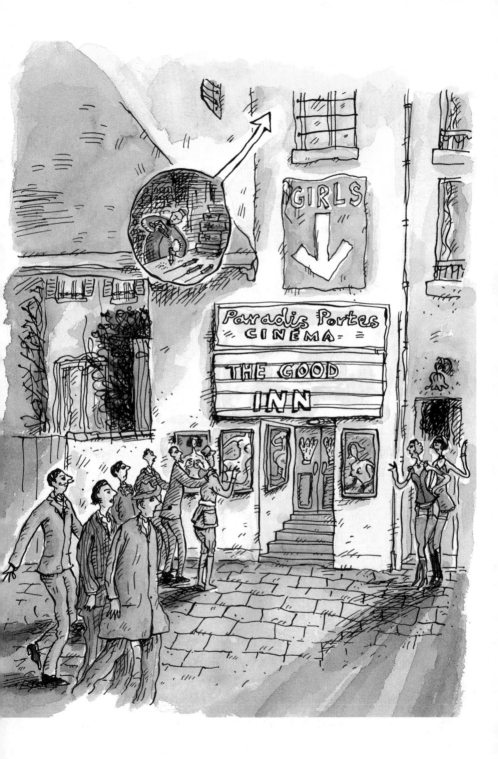

which the city pays to keep lit up,
in place of lighting other stuff.

Around its corner, the gang goes
into an alley that Soldier Boy knows.
From some frightful dream where he was pursued
while searching for his other half, and for his second Nicole.

A shabby marquee flickers and buzzes,
the entrance to Léar's old theater below the Olympia has suffered
many abuses,
behind the new Paris that, like ivy, has covered up and overgrown,
this little lost house of strange cinematic uses.

Just next door, the red salon sits,
a place some call, a house of sin,
a row of small rooms are reserved,
a few women for so many men.

And above the house where these women work,
an old man from the Orient, assembles fireworks of every sort.
Two for three francs, or four for seven.
Business has been slow, so the room is very cramped,
a leak in the pipes has made the fuses all damp,
walls of his creations on all four sides,
an explosive combination, that up until now he has been able to
hide.

In the old theater below, conveniently placed,
a movie is on the marquee to play at the top of each hour,
to give the men a push in the right direction,
to pay for a room and a woman's hourly affection.
Soldier Boy looks up to read the marquee,
the film on the bill is about to begin, it's a silent two-reeler called

The
Good
Inn.

La Maison Rouge du Film Bleu (The Red House of the Blue Movie)

INTERIOR/MOVIE THEATER LOBBY/NIGHT

Soldier Boy watches as his evening companions walk ahead laughing and stumbling through the swinging doors to the single theater.

Pierre stops and turns to Soldier Boy, who has stopped in the lobby, staring at the doors to the theater.

PIERRE: What is it, my friend? What is wrong?

SOLDIER BOY: I'm afraid.

PIERRE: What do you fear, George, our brave Soldier Boy?

SOLDIER BOY: I'm afraid . . . that this is the end.

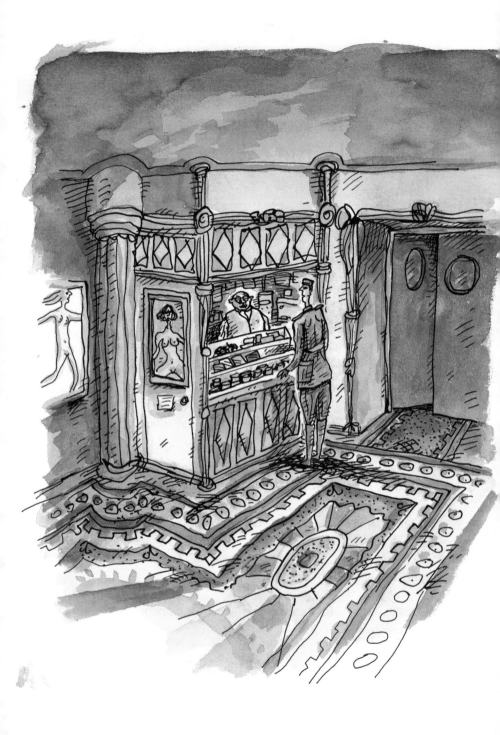

PIERRE: Come on, let us finish off this wild
and wonderful night we have had. There is
ALWAYS tomorrow, although we will be under a
new day's light.

Pierre motions at Soldier Boy to join him and then enters the theater.

Soldier Boy looks to the concession counter, where the Old Projectionist stands, staring straight ahead into nothing, as if in a trance.

A fly lands on the tip of the old man's nose and he jumps to life as he smacks his face with his hand. His nose is bright red from this ritual.

OLD PROJECTIONIST: Your friend is right.
After all, time really is just light in
different places. There is nothing to fear.
Popcorn?

SOLDIER BOY: What?

OLD PROJECTIONIST: Popcorn? Candy? We have a
few treats to offer you to enjoy during the
feature.

SOLDIER BOY: No, thank you.

OLD PROJECTIONIST: My protégé has just fed
the reel in the projection booth. You better
hurry, Soldier Boy, or you'll miss her.

 CUT TO:

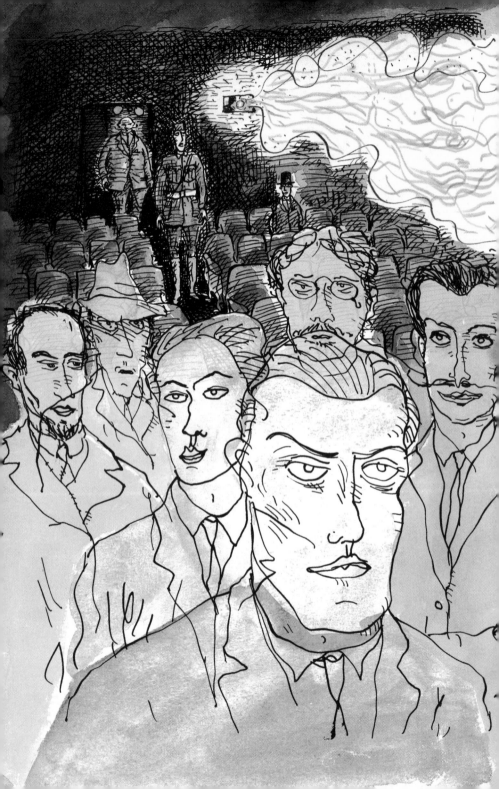

INTERIOR/THEATER/NIGHT

Soldier Boy walks in through the swinging doors. It is very dark except for the flicker of an image on the screen and the beam of light shooting out from the little window above and behind him.

Illuminated by the flickering light, Soldier Boy sees Pierre, Fénéon, Buñuel, Chagall, Breton, and Tati sitting inside. They have joined a larger group, whom Soldier Boy cannot make out, but they appear to be wearing uniforms much like his own.

Looking up, Soldier Boy can see a young man in the booth watching the film on the screen. It is a newsreel that is coming to an end.

On the screen, a report shows a protest in Germany in front of a movie theater with the marquee reading, "All Quiet on the Western Front." Nazi protesters push against German police who are lined up to protect the theater and its patrons. The next report shows a chaotic city street in New York, lines for food, and a report on the early effects of the stock market crash.

<div align="right">CUT TO:</div>

INTERIOR/AUDIENCE/SAME

Fénéon watches the reel in disgust and turns to Pierre, speaking out without warning.

FÉNÉON: You see this? It's all coming down.
You can't hunt down one man for the world's
ills. One man can only do as much harm
to the world as the world allows him. The
great threat is never the one man they hunt
down and put on display in a theater of
redemption. It is the rest of us who created
a world where this all can happen. It is all
of us who should be tried and shot. And they

put me on trial and call me the terrorist? I
should be the judge and jury!

PIERRE: Wonderful, Fénéon. I don't know how
you could see things so darkly. Our city is
the greatest city in the world and we are the
children of the greatest city, whose hearts
beat in time with the artistic avant-garde.
We are quickly becoming the world capital for
freethinking intellectuals, and you think
that such an accomplishment could be undone?
We do not have the problems these other
places do. We are a truly illuminated society.

Fénéon laughs, which is unusual. Everyone notices.

BUÑUEL (with a cigarette dangling from his
lips): Did Fénéon just laugh?

PIERRE: You're surprisingly upbeat tonight.

FÉNÉON: Tonight I've designed what might
be my greatest piece of living social
commentary yet. A theater of the absurd with
a twist. A REAL LIFE *spectacle de curiosité*!
It could be most explosive.

Fénéon turns around in his seat to see Soldier Boy standing in
the back, watching the screen; the theater doors swing open and
standing behind Soldier Boy is Léar.

Léar does not see Soldier Boy standing with his back to him in the
darkness. He scans the dark theater for a face he knows must be there.

LÉAR: Now, what will we observe today? A
two-headed snake confronting its other head
for the first time perhaps.

His eyes stop on a man sitting in a dark corner in the far back, completely out of sight.

Sitting with his face obscured by his overcoat is George.

<div align="right">CUT TO:</div>

INTERIOR/PROJECTION BOOTH/SAME

The Old Projectionist's assistant watches as the end of the film reel pushes through the sprockets and stops on the last frame, where it sticks.

Standing behind him is the Old Projectionist. He is ready to jump in.

OLD PROJECTIONIST: Ah, yes, see.

The young man opens the projector's gate and pulls the last frame out where the light shoots through it.

OLD PROJECTIONIST: It just takes that one frame to stick and for the light to heat it to the right degree, and then . . . BOOM! It all goes up in flames. Very good. Again you have saved us from certain death, until next time.

The Old Projectionist laughs a tired laugh and waddles away out of the booth.

The young man quickly loads the next reel, whose side reads, *La bonne auberge.*

He delicately weaves the film into the projector's track and releases it. As it begins to roll through, the young projectionist turns and walks out of the projection room, closing the door behind him.

The title of the film illuminates the screen.

The Good Inn

And then . . .

The reel stops. The single frame in the window of the lense begins to burn and then ignites. The light BLASTS through the first frame as the reel goes up in flames.

CUT TO:

EXTERIOR/*IÉNA*/DAY (in color)

Soldier Boy stands beside Roussou on the bow of the ship; the morning sun is just about to cut through the horizon. The sky is a brilliant panoply of colors. They stare out at the spectacle of light painting the sky.

On the shore, the silhouette of a woman. For a split second he is sure that it is Nickie, but then Roussou breaks the silence.

ROUSSOU:
"Soldier Boy, do you know what angels are made of?"

Just then the sun cuts through the horizon's line in the sea and for an instant the woman on the shore is illuminated; her peasant clothes give her away. It is not Nickie Willy, "the Queen of the Cancan," but an innkeeper's daughter named Nicole who has finally decided it is her turn to go to Paris.

A BLAST of LIGHT and energy EXPLODES, cutting through Soldier Boy and Roussou, bending their images and then shredding them, carrying their particles away in the light.

<div align="right">CUT TO:</div>

INTERIOR/THEATER/SAME

The explosive light from the screen pushes into Soldier Boy in the back of the theater as he turns away from the blast of energy that rips through the building.

When he looks again at the screen, he finds himself watching his life montaged.

This montage spans from his birth under the Eiffel Tower to the moment he comes upon the Good Inn. It flickers and pops, skipping back and forth in a dizzying, orgasmic spectacle of light through time. And then, Nicole appears on the screen. He watches himself watching her through the window of the inn in the film.

She stops and looks out. It seems that she is looking directly at him.

Soldier Boy is overwhelmed by the experience. He is both transfixed and emotionally overcome. He smiles for the first time.

And then, finally, he speaks . . .

SOLDIER BOY: What a beautiful life I have had.

Soldier Boy stumbles forward down the row of seats, as if in a trance, walking right past his new friends, who sit in the audience watching the picture. Up to the screen he marches, staring into the giant image playing before him.

On the screen now, he watches as he slides up over Nicole and their sexual exploration plays across the screen, all the BEST PARTS seeming to be perfectly edited together.

Behind Soldier Boy in the far dark corner, George stands up. He strains to see who this man is who is standing in front of the screen. Terrified that he will be noticed in the dark, he carefully creeps up behind Soldier Boy and reaches out, almost afraid to touch the shoulder of the man in front of him.

On-screen, Soldier Boy sits in the warm sitting room across from the inn's only other guest, who now clearly resembles Léar.

As George's hand comes down on Soldier Boy's shoulder, a black title card comes onto the screen above.

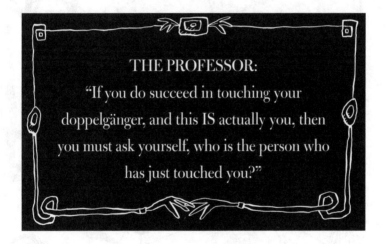

THE PROFESSOR:
"If you do succeed in touching your doppelgänger, and this IS actually you, then you must ask yourself, who is the person who has just touched you?"

INTERIOR/BACK OF THEATER/SAME

The young projectionist stands watching the film, lost in the strange image that now takes over the screen of the soldier looking into a small hole. The rest of the screen is black and it almost seems like he is looking directly at the young projectionist and the audience below—just before he climbs through and the hole swallows everything in darkness.

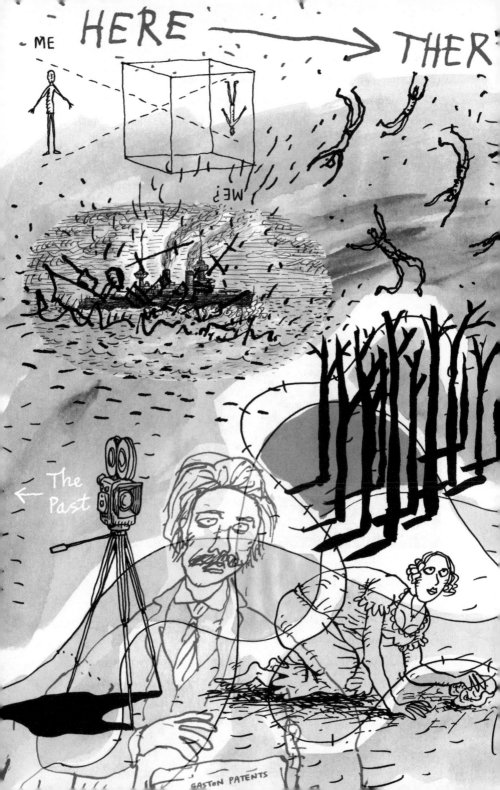

ME HERE → THER

ME?

The Past ←

GASTON PATENTS

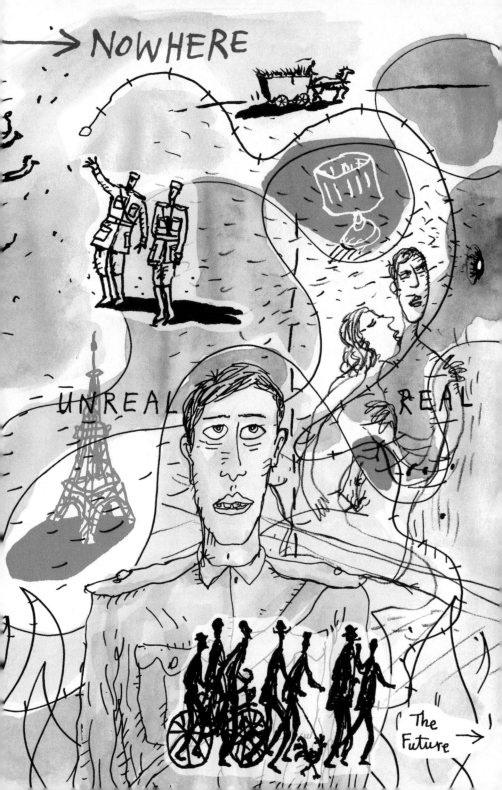

The theater doors swing open and the frantic Old Projectionist rushes in.

OLD PROJECTIONIST:
What have you done?
What have you done?!

He grabs his protégé, shaking him as he looks up to the projection booth, which is in flames.

INTERIOR/FRONT OF THEATER/ SAME

George's hand comes down on Soldier Boy's shoulder and he turns to find himself staring into his own face.

SOLDIER BOY: It's me.

GEORGE: It's you!

SOLDIER BOY: You're me.

GEORGE: I'm you?

On the screen, Nicole now stares into the hole, out at the world that is watching her.

INTERIOR/BACK OF THEATER/SAME

Entering through the same swinging doors, Nickie stands in the back, hidden by the dark of the theater. Looking up onto the screen,

she sees herself, and then looks down to what her younger image on the screen is looking at. There she sees both George and Soldier Boy. There seems to be a struggle happening between the two men. Without thinking, she runs forward down the aisle toward them as Nicole's arm penetrates the hole on the screen, reaching into the darkness beyond.

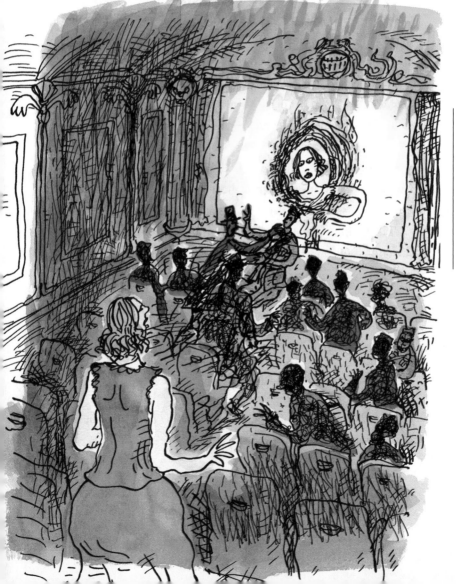

INTERIOR/FRONT OF THEATER/SAME

George has wrapped his hands around Soldier Boy's throat and is choking him to death. Soldier Boy claws at George's hands, but it is no use; George is surprisingly much stronger than he is.

Just as Soldier Boy is about to fade into unconsciousness, a hand reaches out to him, covering him and George in a brilliant light.

It is Nickie's hand. George looks down at his body and is terrified to discover that it is breaking apart into particles of light. He looks into the mirror image of himself, at Soldier Boy, who is also glowing and sparkling into particles of light.

A pinhole beam flickers through the movie screen above, as if they are being projected out of it. Then, as light does when a projector is shut off, it disappears: George, Nickie, and Soldier Boy are gone.

A lone clapping is heard in the theater.

Standing in the glowing smoke-filled theater in the back of the audience, Léar claps as the fire above spreads out over the ceiling. Soldier Boy's late-night party rushes out.

The Old Projectionist grabs his apprentice's arm and begins to drag him frantically up the aisle. As they rush past Léar, he screams out . . .

OLD PROJECTIONIST: Are you mad? The theater is on fire! RUN, RUN LIKE HELL!

LÉAR: But, my dear frazzled friend, I am in ALL my own movies!

The Old Projectionist flees. Léar now stands alone in the burning theater. He takes a seat in the back row.

LÉAR: Ah, yes! Now, now we have our ending!

CUT TO:

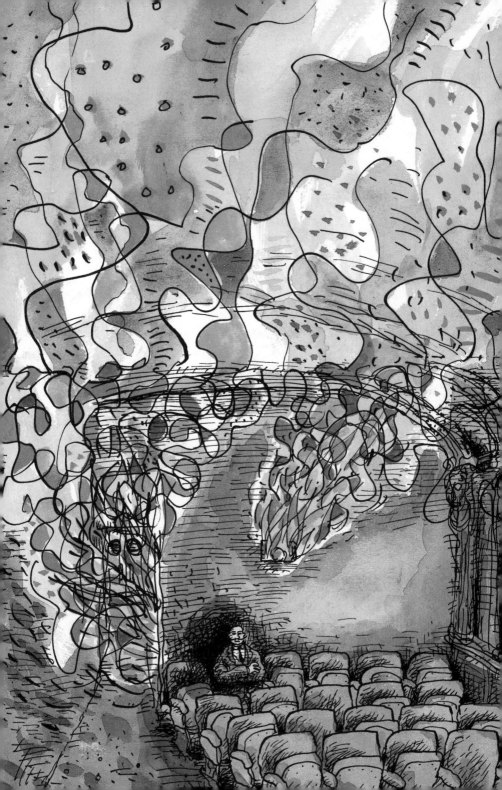

EXTERIOR/*IÉNA*/DAWN (in color)

Over black is heard the sound of sirens, muted screams, and intermittent explosions. Soldier Boy's eyes open to a smoke-filled sky at dawn. The sun has not broken through the horizon.

Music swells and every character from our story sings.

ALL SINGING:

A bird she sang, a little song, I sang along, it's from a film about an inn, that she was in, and as with life there was a plot, but not a lot.

Get to the chorus, she's waiting there for us, we're just the choral ode.

He was alone without his babe, an honest Abe, not a lot of hope a lot of liquor a lot of flicker. He flopped and flipped, just like a fish, I went off script.

Get to the chorus, she's waiting there for us, just a heavy load, just the choral ode.

Soldier Boy tries to sit up but he can't move. He is lying on the pier. Behind him is the ocean and in front of him is his ship, a giant hole in its hull smoking and breaking apart.

Looking down at his body, he sees blood soaking through his uniform. In front of him his precious gift from Roussou, the zoetrope, spins in the wind, first slow and then picking up speed in the breeze. As the little image speeds up to real time he sees that it is a repeating image of a bird in flight.

```
SOLDIER BOY: Cette roue de la vie!
[Subtitle: This wheel of life!]
```

Looking back up to the sky, he sees the same visual, a real bird in flight, and then a face comes into his view. A hand cradles the back of his head and pulls it up.

ALL SINGING:

She never felt very important,
but she is saying something important . . .

Que les anges soient faits de lumière
Et que cette lumière projette ta vie
Scintillante sur un écran perlé
Scintillante devant tes yeux éblouis
Ainsi, vous pouvez dire au revoir
Avant de se joindre à eux dans la lumière.
Que tu puisses ainsi revoir ce que tu as vu
Retourner là où tu as été
Afin de pouvoir dire adieu
Avant de marcher vers le blanc.

SUBTITLE:

That the angels are made of light
And that this light projects your life
Shimmering onto a silver screen
Shimmering in front of your dazzled eyes
So you can say good-bye
Before you join them in the light.
So you can see again what you've seen
Go back to where you've been
So you can say good-bye
Before you march into the white.

She's waiting there for us,
such a heavy load, just the choral ode.

Nicole lifts his damaged body up gently and holds him in her arms. Looking up at her, he gets lost in her gentle, sad smile.

SOLDIER BOY: It's you.

NICOLE: It's me.

SOLDIER BOY: What? Who are you?

NICOLE: Do you know what angels are made of, Soldier Boy?

Before he can answer, the SUN breaks through the smoky horizon. It burns through the thick fog of smoke and fire. All is blue from sea to sky. The sun shines down on Soldier Boy and they are set aglow, sparkling like the sea in front of them.

SOLDIER BOY: Yes. They are made of light!

NICOLE: Yes. They are.

SOLDIER BOY: I never saw you in black and white . . .

NICOLE: That is how you know that I am real.

Soldier Boy's eyes slowly flicker and close.

CUT TO:

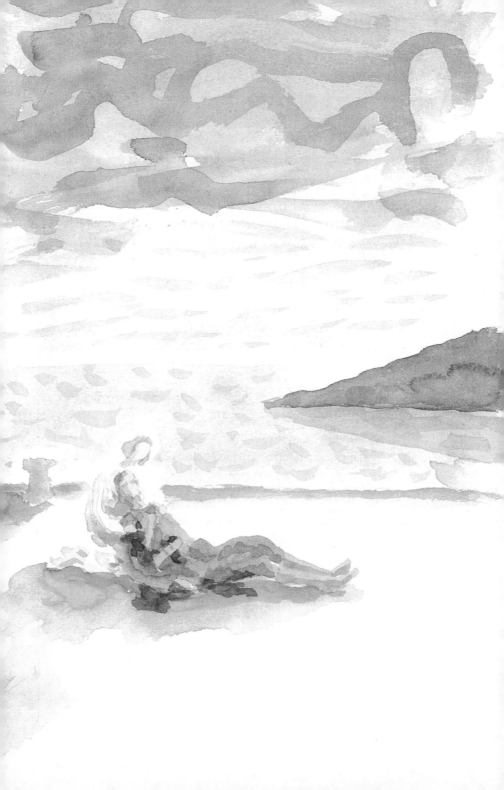

INTERIOR/MOVIE THEATER SCREEN/SAME

The sound of a film projector humming to life.

On the screen . . .

The naked soldier thrusts himself hard against the Innkeeper's daughter as they slide down the wall next to the hole, where light flickers onto them from the other side.

The movie theater image now fills the entire screen.

The Innkeeper's daughter turns him over with force and looks down on him in the final moments leading up to . . .

CUT TO:

EXTERIOR/PARIS/NIGHT

An EXPLOSION. ———————————————————————————

FIREWORK ROCKETS SHOOT up into the sky from HEAT and PRESSURE.

They explode out of the rooftop of the cramped and damp room that separates the thin walls of the red house of sin from the cinema. Above the old theater, now ablaze, the sky is blanketed with every color imaginable. As fireworks shoot up into the night sky over Eiffel's tower, it almost looks like the tower itself is blasting off, above the bright lights of Paris and up into the stars.

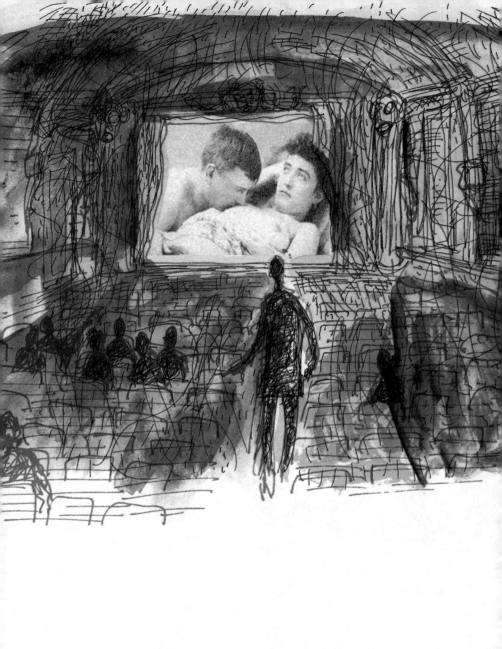

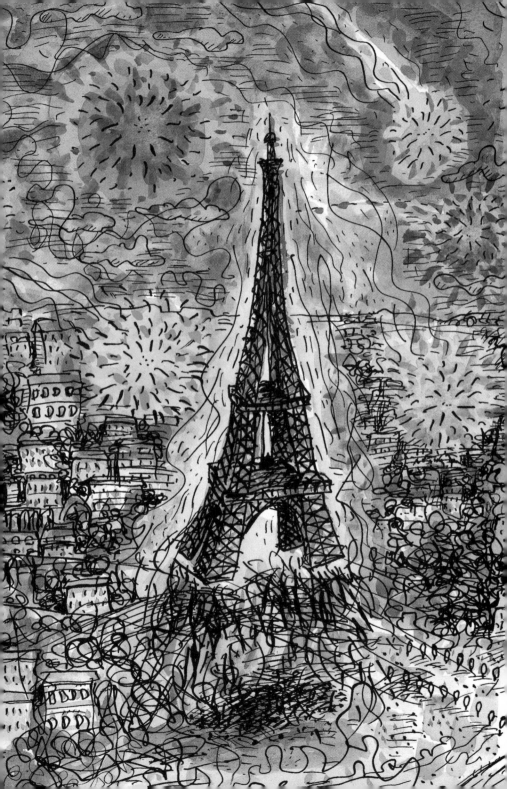

On the burning screen, the soldier's eyes shoot wide open and dilate as his body relaxes. Nicole falls onto his chest with a scream from finishing and . . .

A voice yells out . . . "Cut."

FIN

Epilogue*

Louise (Nickie) Willy . . .

died in 1929 shortly after the events of this tale from exposure and drink.

George . . .

died in the fire in the theater on boulevard des Capucines. His remains were expected to be found upon excavation of the theater. They never were. Like many early silent film stars and Paris stage actors, George was forgotten quickly, as soon as the talkies took over in the early thirties.

Léar . . .

is never mentioned again in the history books after 1901, but it is believed he either was put away in an asylum where he eventually died or he moved to Egypt and started a production company called Léar and Co.

Félix Fénéon . . .

died on February 29, 1944, becoming a small footnote in few history books. During his last year, he burned all the documents and papers he had in his possession.

* Although this tale was a mix of true history and fiction, the epilogue is culled from historically accurate facts.

Bernard Natan . . .

went on to champion Pathé and subsequently be at its helm for its decline. While he was awaiting trial in prison for accusations of fraud, World War II broke out, and the Nazis conquered France. After Natan's release from prison, the French government handed him over to the occupying German authorities. Natan was sent to the Auschwitz concentration camp on September 25, 1942, where he died several weeks later.

Pierre Batcheff . . .

and his costar in Luis Buñuel and Salvador Dalí's film *Un chien Andalou,* Simone Mareuil, both separately committed suicide, Mareuil by setting herself on fire in 1954, Batcheff reportedly by overdosing on Veronal on April 12, 1932.

Nitrocellulose . . .

began to be replaced during the First World War with safer alternative film stocks and many of the original films made with it were recycled to be used in building bombs against the enemies of France.

The Good Inn . . .

was one such film whose chemical makeup was considered at the time to be worth more as weaponry than its price of admission.

The Good Inn,
un film de
Black Francis and Josh Frank

la bonne auberge

Acknowledgments

Thank You

Charles and I couldn't have navigated through this creative process without the guidance and advisement of some very important people. We would especially like to thank Richard Hermitage, Richard Jones, and Charles's supportive family, with Violet Clark at the helm. And of course David Lovering and Joey Santiago, who helped Charles set his initial ideas for *The Good Inn* to music; those early demo recordings helped inspire and sculpt this narrative.

My friend and book agent Michael Harriot and Folio Publishing, and our awesome editor at HarperCollins who championed *The Good Inn,* Denise Oswald, and her amazing team at It Books.

I must thank my father, Steve Frank, whose love and support kept me topside through many storms and explosions on the bow of the boat. My one and only, Jessica, who inspires me every day and fills my life with joy, warmth, light, and peace, and who has proven to me that I can still write really strange stories while football is playing on the TV in an adjoining room. My mother, Marcia; Rich; sister Rachel and brother Scott. My second parents, Carol and Stan Shapiro, who round out my wonderful family support team.

My personal creative team and dear friends, including my

longtime personal editor, Rebecca Ramirez. Jaclynn Pardue for early editorial assistance. Didier Gertsch for translation, historical research, and moral support. I must also thank Todd Komarnicki and Jonathan Coleman for my two-year crash course in screenplay rewrites; without them I could never have written this with such confidence and conviction.

And of course this book would not have been possible without my collaborators, whom I can't thank enough for giving me the opportunity to create something so special and unique with two of my favorite artists and friends in the world, Steve Appleby and Charles Thompson.

—Josh Frank

2014

ACKNOWLEDGMENTS

About the Authors

Black Francis (born Charles Thompson and a.k.a. Frank Black) is the founder, singer, guitarist, and primary creative force behind the acclaimed indie rock band the Pixies. Following the band's breakup in 1993, he embarked on a solo career under the name Frank Black. He re-formed the Pixies in 2004 and continues to release solo records and tour as a solo artist, having readopted the Black Francis stage name in 2007.

Josh Frank is a writer, producer, director, and composer. He is the author of *Fool the World: The Oral History of the Band Called Pixies* and *In Heaven Everything Is Fine: The Unsolved Life of Peter Ivers and the Lost History of New Wave Theatre*. Frank has worked with some of the most innovative musicians, filmmakers, producers, and artists in the entertainment industry, including Black Francis, David Lynch, Mark Vonnegut, and Harold Ramis. He has interviewed more than four hundred of America's most notable names in show business for his books and screenplays. In his spare time he runs his mini urban drive-in movie theaters in Austin, Texas, and Miami, Florida.

Steven Appleby is an absurdist. He is the creator of comic strips for newspapers, a radio series for the BBC, a musical theatre show, and

the animated television series *Captain Star*. He has published over twenty-five books, and his paintings and drawings have appeared in numerous gallery exhibitions and, notably, on the Pixies' album *Trompe Le Monde*. He lives, works, and daydreams among his unusual family in London.